KT-467-863

realism

KERSTIN STREMMEL
UTA GROSENICK (ED.)

TASCHEN

HONG KONG KÖLN LONDON LOS ANGELES MADRID PARIS TOKYO

content

The Truth
of the visible

1. GUSTAVE COURBET
The Realist Manifesto
1855

2. GUSTAVE COURBET
The Artist's Studio
1855, oil on canvas, 359 x 598 cm
Paris, Musée d'Orsay

Following an abundance of stylistic tendencies – Expressionism, Futurism, Vorticism and Cubism – which needed some getting used to at first, the return of Realism in the 20th century occasioned a sigh of relief amongst more than a few art-lovers. It was formulated by the art historian Hans Hildebrandt in his 1931 standard work "Die Kunst des 19. und 20. Jahrhunderts" (The Art of the 19th and 20th Centuries) as follows: "Among all the movements of the 20th century, New Realism is the easiest to understand and the most popular. We need only to mention the generally familiar term Neue Sachlichkeit: no further proof is needed." The popular aspect of this so-called New Realism seems to be that there it was nothing really new about it. But in the course of the century, we departed a very long way from this new clarity. The spectrum of what is generously understood by Realism ranges from Photo-realism to Capitalist Realism, from Material Realism to Cool Realism, not to mention Relativizing Realism.

The original semantic field covered by the term "realism" – as far as the visual arts were concerned – was more constrained: it denoted a 19th-century artistic style which was the first in the history of art to call itself realistic, and it did this with the express purpose of drawing a line between itself and its idealistic opposite numbers. Gustave Courbet (1819–1877) was attacked by art critics as a "realist" on

account of works like the *Stonebreakers*, dating from 1850, with its coarse, pasty technique bereft of any idealizing tendency. However, he made a virtue of the criticism. Rejected by the Paris Salon, on the occasion of the 1855 World Exhibition he displayed his pictures in a shed which he christened the "Pavillon du Réalisme". The same year, he composed the influential "Realist Manifesto" (ill. 1), which, in full knowledge of existing artistic traditions, advocated an individualistic art which had to come to terms with the mores and customs of its age and of the reality of life around it.

Courbet's programmatic painting *The Artist's Studio (A real allegory of a seven-year phase in my artistic and moral life*; ill. 2) makes it clear that he was interested in reality in its various manifestations: this vast work, painted in 1855, depicts him working on a landscape set in his native Franche-Comté; beside him are a nude young woman, a shepherd boy, and a cat, while to the right there is a group of Courbet's friends, all of whom can be identified, including the author Charles Baudelaire, the social theorist Pierre Joseph Proudhon and Alfred Bruyas, a patron of Realistic art; the left-hand side of the picture is occupied by figures symbolizing among other things work, commerce, and academic art.

The aforementioned nude, referred to by contemporary critics as the "muse of truth", is a frequently quoted example of a style of

1900 — World's first escalator presented at the World Exhibition in Paris
1902 — Lenin writes the manifesto "What is to be done?" 1903 — Henry Ford founds the Ford Motor Company in Detroit

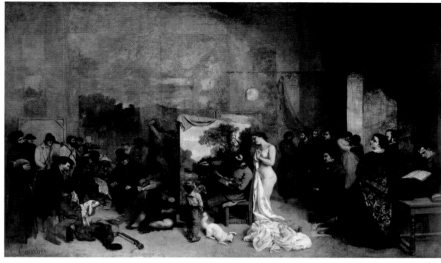

1

2

"The perfect painter must be able to scrape off his best composition ten times in a row and each time paint it anew in order to demonstrate that he depends neither on his nerves nor chance."

Gustave Courbet

painting which obtained its motifs from photography: the figure was inspired by a nude photograph taken by Julien de Vallou Villeneuve. This integration of a photographic "original" makes the point still more obviously that the painter acknowledged and accepted the contemporary world. At the same time, it points to the fact that the invention of photography had set in motion a process which had fundamentally changed the art of painting. In the year the first photograph was taken, the painter Paul Delaroche uttered the much quoted comment: "From today, painting is dead!"; this was the starting-point of a process of mutual influence and attempts at mutual demarcation which still continues and is still productive — as can be seen in almost every so-called "realist" painting.

However, Realism refers not only to the idea of a particular era which, following Courbet, was continued in France above all by that "painter of modern life" (a term coined by Baudelaire and applied to Manet), Edouard Manet, with his predilection for motifs taken from the world of everyday, but also to a method of depiction. The term is often used synonymously with Naturalism to refer to an attempt at true-to-life reproduction of external reality. In the history of art, Realism did not begin in the 19th century: so-called realistic tendencies have existed throughout the history of art since Classical Antiquity. By "Realism" in this sense — in contradistinction for example to idealis-

tically oriented programmes — we understand any attempt at the faithful depiction of visible reality in painting, sculpture and the graphic arts. Unlike the Greek sculptures of Classical times, which strove to represent a generalized ideal, the "character heads" of the Hellenistic period were marked by individual and realistic features. In landscape painting, for example, the discovery of perspective at the time of the Renaissance was a turning-point, while in the sphere of portraiture, artists such as Albrecht Dürer, Hans Holbein the Younger and Lucas Cranach the Elder were pioneers of realistic depiction. The famous *Great Piece of Turf* (1503) by Dürer is still regarded today as a model for the accurate study of nature.

Where the still-life is concerned, illusionism has traditionally played a major role. Time and again, artists have quoted Pliny the Elder, who, in his *Natural History*, said of the painter Zeuxis that his grapes were so lifelike that real birds would try to peck at them. Zeuxis in his turn was deceived by a rival painter, Parrhasios, whose painted curtain he tried to draw aside. Caravaggio's *Fruit Basket*, dating from 1598/99 (ill. 3), believed for centuries to be a Netherlandish *trompe-l'œil* painting, was the result of an obsessive study of the objects depicted: a basket filled with fruit, some of it rotting, and withered leaves, with a clear emphasis on the aspect of *vanitas*, of transience. One particular attempt in the following century to deceive the

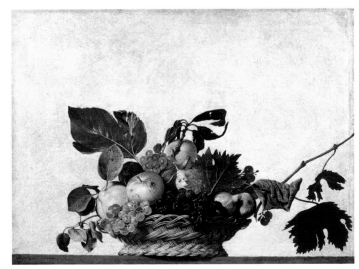

3. CARAVAGGIO
<u>The Fruit Basket</u>
c. 1598/99, oil on canvas, 31 x 47 cm
Milan, Pinacoteca Ambrosiana

4. SEPP HILZ
<u>Peasant Venus</u>
c. 1938, oil on canvas, dimensions not available
Private collection

5. ALEXANDER GERASSIMOV
<u>Portrait of Stalin</u>
1939, oil on canvas, 137 x 112 cm
Moscow, ROSIZO State Museum and Exhibition
Centre

3

eye even led to a picture which comes across as verging on the abstract: Cornelis Norbertus Gijsbrechts' *Reverse of a Painting*, dating from 1670, consists of the careful reproduction of a wooden frame and a canvas seen from behind, even including an apparently pinned-on catalogue number. This *betriegertje* was probably included in a sales exhibition as a joke.

Joking apart, the debate about the function of art between imitation on the one hand and autonomy on the other was conducted with great seriousness. Thus in the 5th and 4th centuries BCE, Greek art saw a paradigm shift from Idealism to Realism, as reflected in the story of Alexander the Great's horse, which is said to have neighed in welcome when it saw its painted image. Since then, Idealism has continually had to face the charge of academicism, while Realism has by contrast been written off as the mere copying of reality.

Realistic depiction can however also embrace the interpretation and evaluation of the depicted motif. The most vehement rejection of the representational model of art came in the 20th century: the art critic Clement Greenberg, an advocate of artistic autonomy, expressed it thus: "What modernist painting has abandoned in principle is the representation of the kind of space that recognizable objects can inhabit."

But even in the 20th century there were variations on the theme of a productive confrontation with reality: variations which contradict the notion that mimesis is synonymous with imitation. As evidence of a new relationship between art and reality, we can adduce the remark with which Paul Klee began his 1920 essay *Schöpferische Konfessionen* (Creative Confessions): "Art does not reproduce visible things, but renders things visible." And does not even the most precise imitation, the most passive reproduction, represent the expression of a choice?

The confusion surrounding styles in the 20th century is increased still further by the fact that the same terms are applied to very different manifestations of Realism. Thus Nouveau Réalisme and its American offshoot New Realism are terms applied traditionally to the concrete appropriation of "reality" as a logical extension of the "ready-made" concept. At the same time, however, the term is also used to characterize, for example, the style of Philip Pearlstein in order thus to suggest that his painting technique is different from earlier manifestations of Realism. And if this were not confusing enough, the same phenomenon is sometimes referred to in different ways; thus Photo-realism, by virtue of its technical perfection, is also known as Super-realism or Hyper-realism.

1913 — The Armory Show of modern European art in New York

1914 — Outbreak of First World War

> **"Realism is
> not a manner,
> but an approach
> and an aim."**
>
> John Berger

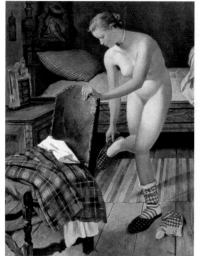

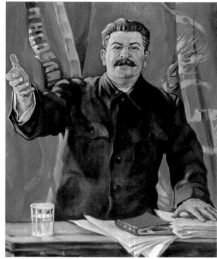

4 5

> **"Art must be
> understood and loved
> by the masses."**
>
> Lenin

A question of form? or perhaps not.

For all the optimism shown by Bertolt Brecht in his attempt to characterize the phenomenon – "Realism is not what real things are like, but what things are really like" –, there are also problems in delineating the field covered by Realism, for various parties make use of the same form of picture. This was noted already 1925 by Franz Roh in his foundation work on so-called Post-Expressionism, by which he sought to encompass the "realistic" phenomena of the 1920s: "Thus the left-leaning group, including those within Post-Expressionism, are opening up all the wounds which were trying, prematurely, to close ('in order only to prolong the judgement'), while the right-leaning group, the idyllic party, are closing or cooling the wounds, or seeking, by the generation of inner comfort and warmth, to dry them out. (The fact that both parties use the same Post-Expressionist form of picture is just one of those puzzles of artistic development that we have to accept.)"

The same phenomenon also appears in American manifestations of Realism, where the industrial pictures of Charles Sheeler for example developed out of the anti-academic attitude of the so-called Ashcan School centring on Robert Henri, which devoted itself to the ugliness of everyday street-scenes, at the same time as the emergence of rural American Regionalism in the style of Thomas Hart Benton or Grant Wood, with its populist-conservative pictorial world. And it was from precisely this romanticizing Regionalism that another pupil of Robert Henri, Edward Hopper, with his subdued pictorial inventiveness, distanced himself as far as he possibly could.

In this sense, it would seem to be questionable, indeed wrong, to see Realism in negative ideological terms, as has often been done, for example by Hans H. Hofstätter in 1961: "The 1930s witnessed an emotional intensification of the Realism of the 1920s, leading directly to the Realistic painting of the Third Reich and later to 'Socialist Realism.'"

For one thing, this approach is unfair to the Neue Sachlichkeit artists: no major exponent went over to the "clean" Realism of the Nazis, and most of them were rapidly denounced as "degenerate". Furthermore, in the following period, reality-related forms of expression were anyway not accepted. It is perfectly obvious that the crude Realism of the National Socialists led to a general reaction, and even Franz Roh, the early theoretician of Neue Sachlichkeit, blamed himself in 1952 for not having recognized during the 1920s that abstraction was the "greatest discovery of our century".

As a result of the Cold War, the "Communist-Nazi" thesis became commonplace, leading at first to a veritable dictatorship of

1915 — Heinrich Wölfflin writes "Kunstgeschichtliche Grundbegriffe" (Basic Concepts in Art History)
 1915 — Albert Einstein publishes his General Theory of Relativity

6 7

Abstract Art in the West, which only began to soften in the late 1960s. The thesis stated that anyone in the 1950s who painted figurative subjects was a reactionary. Karl Hofer, who had been forbidden to paint during the Nazi era, and whose works were denounced as degenerate, said of himself in the early 1950s: "My container bears the label: sclerotic, retarded, figurative." Western critics, such as the American art expert Alfred Barr in 1953, conducted a passionate polemic against all figurative art, voting for Abstraction on the grounds that Realism and Totalitarianism belonged together.

subjective тruths

When we consider the works of art that received official approval during the regime of that failed artist Adolf Hitler, we can almost begin to understand this blanket rejection of every figurative approach to the world. The stifling by the Nazis of all avant-garde tendencies and the return to the allegedly "accessible" innocuities of the 19th century was so thoroughgoing as to drag the quality of art production during this period to well below the level of the other dictatorships, Italy and the Soviet Union. The pictures by Adolf Ziegler, who in his capacity as curator of the "Degenerate Art" exhibition had confis-

cated the works of 112 artists from German museums, represent one of the bleak summits of Nazi Realism; his stolidly pernickety technique led to his being nicknamed the "Master of the Pubic Hair". With its obvious suggestions of naturalness and virtue, the hackneyed *Peasant Venus* (ill. 4), painted by Sepp Hilz in about 1938, a genre painting and nude at the same time, also stakes its claim to a place in the gallery of Nazi aesthetics: cosy peasant parlours and weathered peasant faces have become the hallmark of a kitschified ideal world which has nothing in common with any true-to-life representation of reality.

It cannot be denied, however, that there are parallels between art under the Nazi regime on the one hand and Socialist Realism on the other, for neither political system accepted anything which contradicted the official doctrine of social reality. Since the most important criterion for the production of art which reflected this reality was its general "accessibility", one of the results was a uniformity of the formal means employed. This was formulated by Otto Nagel, the President of the "3rd German Art Exhibition" in Dresden (in communist East Germany) in 1953 as follows: "The language of the artists is clear and comprehensible, and demonstrates the serious endeavour to meet the just demands of ordinary people. Taking the classical tradition of German realistic art as its starting point, our visual art is start-

1916 — Trans-Siberian Railway completed 1917 — Bolshevik Revolution in Russia brings Lenin to power
1918 — More than 20 million people die of Spanish flu

6. NOUVEAUX RÉALISTES

<u>Foundation manifesto</u>
27 October 1960
The Nouveaux Réalistes became aware of their
shared uniqueness.
Nouveaux Réalistes = new ways of perceiving reality
Yves le monochrome, Martial Raysse, Restany,
Arman, Tinguely, Spoerri-Feinstein, Villeglé, Hains,
F. Dufrêne

7.

<u>The New Realists with Yves Klein</u>
From left to right: Arman, Jean Tinguely, Niki
de Saint Phalle, Günther Uecker, Daniel Spoerri,
Jacques de la Villeglé

8. PABLO PICASSO

<u>Gertrude Stein</u>
1906, oil on canvas, 100 x 81.3 cm
New York, The Metropolitan Museum of Art,
Bequest of Gertrude Stein

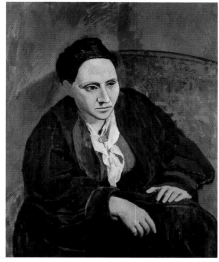

8

"I always take pains to lose sight of nature. I am concerned with verisimilitude, a deeper verisimilitude that is more real than reality…"

Pablo Picasso

ing to raise itself to new heights of beauty." This demand that art be comprehensible, or in the current phrase, "accessible", was expressed time and again under both political systems, and in addition, both in equal measure claimed to be representing objective truth. Baldur von Schirach, head of the Nazi youth movements and Gauleiter of Vienna, said at the opening of one exhibition in 1941, that art served "not reality, but truth"; and it goes without saying that the sentimental depiction of the joys of motherhood, for example, in Socialist Realism was inspired by the desire for truthfulness.

Socialist Realism, understood as the highest form of artistic development, was to obey the definition coined by Friedrich Engels in respect of Honoré de Balzac: "In my opinion, Realism means, alongside fidelity to detail, the faithful reproduction of typical characters in typical circumstances." Important, then, is not true-to-life depiction of reality in all its details, but the representation of the "essentials", the "truth" about reality, whereby concrete reality must always be taken as the starting point.

We need to remind ourselves in this connexion that the Bolshevik Revolution of 1917 had at first promoted the artistic avant-garde. Innovative Constructivists were among those who offered their services to the new regime. But Stalin decided in favour of a different aesthetic – namely that of monumental kitsch. He prescribed Socialist Realism and had himself stylized as its patron. Alexander Gerassimov's portrait of Stalin (ill. 5), dating from 1939, shows the dictator heavily idealized as usual, broad-shouldered, with a tumbler of water in front of him on the rostrum. Flattering idealization can hardly be regarded as an invention of the 20th century, however; portraits of rulers in earlier epochs are also characterized by not showing their sitters "warts and all". But precisely such portraits as this one of Stalin can be adduced as evidence that the description "Socialist Realism" should, to be honest, have been replaced by "Socialist Idealism".

Already in the later years of communist East Germany, though, non-doctrinaire tendencies were also making themselves felt, and now that all the 20th-century would-be utopias have gone the way of all flesh, the question of which truth and which reality artists can work on remains an open one. In principle, we have to ask what kind of relationship exists between the object and its image, for this object is not simply the world as it is, or the world as it looks, and not necessarily the way we see it. Rather, it is a matter of different kinds of transformation, which point to a remarkable phenomenon, namely that Realism is characterized more by differences than by common traits. Those realistic works which capture our attention for reasons other than historical interest seem, universally, to be exceptions to any general definition.

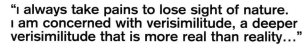

1919 — Versailles Peace Treaty **1922 — Friedrich Wilhelm Murnau makes the film "Nosferatu"**
1922 — The March on Rome ushers in the Fascist regime in Italy

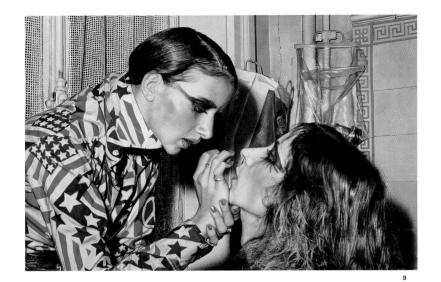

9. FRANZ GERTSCH
<u>Marina Putting Make-up on Luciano</u>
1975, acrylic on unprimed canvas,
234 x 346.5 cm
Cologne, Museum Ludwig

10. ROBERT BECHTLE
<u>Marin Avenue – Late Afternoon</u>
1998, oil on canvas, 92 x 167,6 cm
Courtesy Barbara Gladstone Gallery,
New York

9

nothing but exceptions

Even the Mexican revolutionary painters José Clemente Orozco, Diego Rivera and David Alfaro Siqueiros are regarded as significant special cases, to say nothing of the abundance of unique phenomena which make leafing through the present book anything but monotonous: Balthus' tender nymphets are no less an unmistakably autonomous part of the international current of Realism in the inter-war period than Giorgio Morandi's ascetic still-lifes, Tamara de Lempicka's metallic women or Edward Hopper's filmic interiors. Philip Pearlstein's involved anonymous nudes are depicted in a way no less singular than Lucian Freud's characteristic naked portraits. And among all these unmistakable artists who are lumped together in extremely loose fashion by the "Realist" label, there are some whose individual works are themselves characterized by stylistic pluralism.

One example, who is as well-known as he is convincing, is Pablo Picasso, who, towards the end of his life, described style as a kind of prison from which he had always succeeded in escaping, albeit at the cost of having no style of his own: "I mix things up too much, I move things too much… and that's why I have no style." However, we can certainly understand his conviction that different motifs also require different methods of representation.

So from Picasso we have not only the first collage, the *Still-life with Chair Caning*, dating from 1912, in which he integrates a fragment of the real world into the picture, making him, if you like, a precursor of Nouveau Réalisme, but also the Portrait of *Gertrude Stein* (ill. 8), which he painted in numerous sittings from 1905 to 1906. At first, critics complained of the poor likeness, but Picasso knew from the outset that she would look like that one day.

In Stein's *Autobiography of Alice B. Toklas* she wrote: "It was not until a few years ago that Gertrude Stein decided to cut off her hair; until then, she had worn it done as a crown, just as Picasso had painted it. Having now cut off her hair, she happened to go into a room, and Picasso was two rooms away. She wore a hat, but he espied her through two doorways, ran up to her, and cried: Gertrude, what's up? What do you mean, Pablo? she asked. Show me, he said. She showed him. And my portrait, he said sharply. Then his expression grew softer, and he said: Quand même, tout y est. (Even so, it's all there.)"

The massive figure of the American writer plays a bigger role in Picasso's depiction than the detailed reproduction of the individual facial features. In its totality, however, it creates the impression of a strong character, by using stylistic means which, while heralding the artist's journey to Cubism, can nevertheless certainly be called realistic.

--
1925 — "Neue Sachlichkeit" exhibition in Mannheim
1925 — Sergei Eisenstein's film "The Battleship Potemkin" shown in cinemas
--

10

"when ı'm photographing a car in front of a house ı try to keep in mind what a real-estate photographer would do if he were taking a picture of the house and try for that quality."

Robert Bechtle

It is precisely in connexion with Picasso's works that we have to ask the fundamental question: What is more realistic, what is the least-falsified image of the real: a fragment of material integrated into a collage, a literal part of reality later claimed by the Nouveaux Réalistes to represent "authentic realism" – or a painted illusion or photograph? To return once more to the concept of uniqueness: the Nouveau Réalisme manifesto mentions that the members of the group are aware of their collective uniqueness (ill. 6).

The Nouveau Réaliste group (ill. 7) was composed of such different artists as Arman, César, Christo, Gérard Deschamps, François Dufrêne, Raymond Hains, Yves Klein, Martial Raysse, Mimmo Rotella, Niki de Saint Phalle, Daniel Spoerri, Jean Tinguely and Jacques de la Villeglé, who worked with very different techniques: from décollage, in other words the demolition of placards, as practised by the so-called Affichistes (French *affiche* = poster), to Assemblages, Accumulations and Compressions and on to mobile sculptures made of scrap and waste materials.

There was however a feature which linked them all: the wish for real objects and materials from the everyday world, often waste or scrap, to take on a new presence by dint of artistic alienation. In this way these artists hoped at the same time to provide an unaccustomed view of reality; thus the French critic Pierre Restany, the group's initi-

ator, came up with the formula "Nouveau Réalisme = new ways of perceiving the real". The intention was therefore also to express aesthetic criticism of the consumer world, of bourgeois possessiveness, and of a specious commodity aesthetic. By rejecting all illusion along with the concept of a traditional picture, the Nouveaux Réalistes were paying homage to Marcel Duchamp: his display of a signed urinal – using real elements of the everyday world to make a gesture critical of the established art business – can also be interpreted as a particular form of Realism.

While the group broke up in Milan in 1970, some of the artists involved continue with a technique which relates to "the real as such". We have only to think of Christo and Jeanne-Claude's ongoing "shroudings", which now take the form of spectacular operations. Action Art, Body Art and Land Art, all dispensing with the autonomous two-dimensional picture, also keep up the tradition of Duchamp's rejection of imitation while continuing the attempt at a *mise en scène* and demonstration of reality. If we extend Realism to include all these phenomena, however, the field becomes too large to encompass in any useful fashion.

1927 — Charles Lindbergh flies alone non-stop from New York to Paris

1927 — Werner Heisenberg publishes his work on the Uncertainty Principle

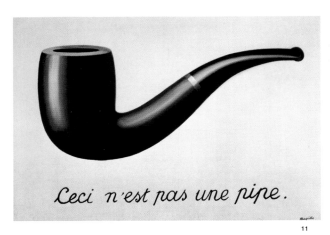

11

"we all have to be con-
scious of the possible
catastrophe which could
hit us at any given
moment of the day."

Francis Bacon

Photogenic Painting

Those who continued to paint realistically in the post-Duchamp world found themselves having to meet stiffer requirements. Apart from a certain aversion to pure depiction, expressed in a reserved attitude towards imitation, photography played a decisive role in the development of painting in the 20th century. Even in the 19th, its invention had caused numerous painters to abandon visible reality as a subject and to concentrate instead on formal innovation and abstract qualities. This trend continued in the 20th century, while the establishment of photography as an artistic medium in itself led to painting distancing itself even more strongly from visible reality. In his book *L'acte photographique* (The Photographic Act), Philippe Dubois spoke of a polarization which assigned to painting the functions of art and imagination, while photography was accorded those of documentation and reference, concentrating on concrete content.

The common feature of all those artists whose work can be described as realistic seems to be that their techniques represent a confrontation with the medium of photography. This is most obviously true of the Photo-realists, who since the 1970s have been meticulously copying, in paint, motifs in most cases projected on to the wall by means of a slide projector.

In addition, photography can serve as material for the imagination in all sorts of very different ways. For example we could mention one method used by Eric Fischl, who re-assembles photographs and processes them on the computer screen, or Francis Bacon, who uses photographs as the eventually almost unrecognizable starting-points for his approximations to reality. This has been taken so far that Gerhard Richter has said in relation to the relationship between the two media: "The photo is not an aid to painting; rather, painting is an aid to creating a photo using the methods of painting."

These techniques are far removed from what Michel Foucault critically observed of the conventional practitioners of Photogenic Painting, namely that they used transparencies in the way that Guardi, Canaletto and many others used the *camera obscura*: in order to trace a projected picture with a crayon, and thus obtain a perfectly accurate sketch; in other words to capture a shape. But only in its confrontation with those traces which reality leaves on the photographic plate does 20th-century painting seem to have found itself. The diverse approaches show how little uniformity there is in Realism, in the sense of "dealing with reality".

The tautologies of the Photo-realists can be linked to the ideas of René Magritte. His 1928/29 painting *The Treachery of Pictures* (ill. 11), which he executed in a number of versions, is a reflexion on

1928 — The foxtrot "Es liegt in der Luft eine Sachlichkeit" becomes a fashionable hit
1928 — Premiere of "The Threepenny Opera" by Bertolt Brecht and Kurt Weill in Berlin

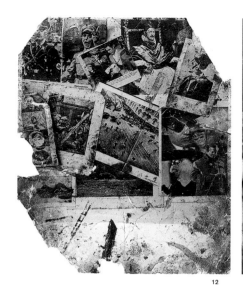

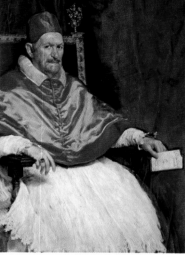

11. **RENÉ MAGRITTE**
The Treachery of Pictures
1928/29, oil on canvas, 62,2 x 81 cm
Los Angeles, Los Angeles County Museum of Art

12. **SAM HUNTER**
Bacon's source material in the artist's studio
1950, photograph, 30 x 24 cm

13. **VELÁZQUEZ**
Innocent X
1650, oil on canvas, 140 x 120 cm
Rome, Galleria Doria Pamphilj

12 13

the paradoxical relationship between realistic painting and reality. Beneath an accurately painted object we read: "Ceci n'est pas une pipe", for indeed, the painted pipe is not a real pipe. This playing with reality is reflected in the works of the Photo-realists, whose starting point is not reality itself, but the indirect reality of the photograph they are using. In this sense the photograph is not merely an aid, as it was, surreptitiously, for 19th-century painters, but the deliberate starting situation for the picture.

"тροppo vero" – too honest?

Robert Bechtle (b. 1932) was one of the leading early Photo-realists. His work centres on the faceless sunlit streets of Californian suburbs. He has taught painting at San Francisco State University since 1968, and always concerned himself with his familiar surroundings in the bright California light, an atmospheric feature which makes his pictures instantly recognizable.

Marin Avenue – Late Afternoon (1998; ill. 10) can be seen as further proof of the menace that can emanate from the banal: in the middle of the deserted scene we see a greyish-blue car, its colour matching that of the sky, outside a house with curtains drawn. The certain feeling that the idyll is deceptive results from the uniformity of what is represented: there is no visible individuality, the impression rests on pure supposition, saturated by the experience of life or of films: anyone who has discovered, in David Lynch's film "Blue Velvet", the evil in the idyll, will always have certain doubts about the façade.

In his depictions of people, too, Bechtle succeeds in transforming banal situations into a symbol of alienation. The unbridgeable distance between the depicted persons comes across like a sympathetic continuation of the scenarios of Edward Hopper. The reason, no matter whether we're talking about pictures of people, cars or streetscenes, lies in the choice of suitable photographs, which provide Bechtle with precisely that degree of authenticity which he needs for the sake of plausibility.

In the process, he tries not to make too much of an effort to compose the photographic image, but rather to maintain a certain neutrality, which forces beholders of the resulting painting to approach the subject without presuming that they know the painter's intention. Bechtle is not concerned to make fun of a particular lifestyle or to deliver sociological commentaries. But the impression of distance can lead to a critical analysis of what is depicted.

In contrast to the objectively subdued pictorial language of, for example, Richard Estes and Audrey Flack, which is intensified by their

1929 — "Black Friday": the Wall Street crash 1930 — Chrysler Building completed in New York
1935 — "Blood and Soil" exhibition in Munich 1935 — Nylon invented

15

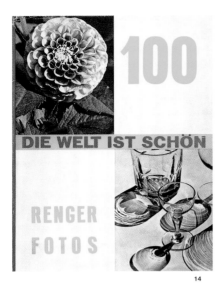

14. ALBERT RENGER-PATZSCH
"Die Welt ist schön"
1928, cover
Zülpich, Albert Renger-Patzsch-Archiv,
Ann und Jürgen Wilde

15. HANS FINSLER
Electric Light-bulb
1928, Black-and-white photograph, 19 x 13.7 cm
Halle, Staatliche Galerie Moritzburg

16. RUDOLF DISCHINGER
Electric Cooker
1931, pencil, 57 x 68 cm
Stuttgart, Staatsgalerie Stuttgart

14

use of the airbrush technique, Bechtle's brush-strokes are visible. And there is a certain expressiveness which distinguishes him from the so-called Cool Realists, who copy their originals meticulously.

The Swiss artist Franz Gertsch (b. 1930), who evolved his personal style from the late 1960s, independently of Photo-realist developments in America, by transforming photographs he and others had taken into gigantic, meticulously coloured paintings, also has a specific view of reality. He paints people in carefully chosen situations: in contrast to, for example, Chuck Close's objectivized facial land-scapes, however, Gertsch emphasizes a quasi-romantic relationship with the sitter. In addition, Gertsch is fascinated by the challenge of transforming the light of the projected transparency – one might also say the transparency of the projected light – into paint. *Marina Putting Make-up on Luciano* (ill. 9), dating from 1975, depicts the successful transformation of a man into a woman; the perfection with which the woman in drag makes up the male transvestite can be seen as the symbol of the transformation executed by the artist, who transfers every detail in phosphorescent paints on unprimed canvas – a tech-nique which virtually excludes subsequent corrections – and treats every inch of the painting with the same attentiveness.

Less true to detail than these Photo-realist essays are the pic-tures by Alex Katz (b. 1927), whose pride in the decorative quality of his paintings is impossible to overlook. *January Morning in 1992* (ill. 18) is a bust of an attractive woman with a soft purple cap, bright-red lips, a scarf which takes up both colours in elegant fashion, and wideawake, somewhat sceptical eyes looking out from a well-tailored face. In the background, the bare branches of trees are outlined against empty whiteness – snow or fog. In its quasi-abstract formal language, the picture conveys at the same time loneliness and self-confidence, distance and presence. The limpid face becomes the pro-jection surface: Katz goes much further than merely presenting a banal surface in poster-like fashion, even though his pictorial lan-guage is influenced by advertising. And at the same time one can say of his works the same as what he himself has said of those of Julian Schnabel: "People look wonderful in front of these paintings." In an interview with David Sylvester, Katz has described the difficulties some recipients have had with his pictures: "I think some people find it hard to accept that as being art – elegance and beauty – they want to see social messages, suffering, inner expression, all of those things which I'm not interested in."

In this sense his work is diametrically opposed to the dark images of damaged life painted by Francis Bacon, whose interest was directed towards the search for a new form of figurative picture, as he explained in a series of interviews with the same David Sylvester. Pho-

1936 — Outbreak of Spanish Civil War　　　　1936 — Charlie Chaplin makes the film "Modern Times"
1936 — African-American athlete Jesse Owens wins four gold medals at Berlin Olympics

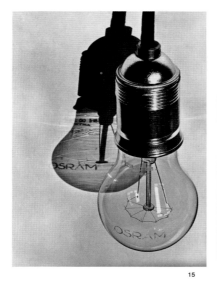

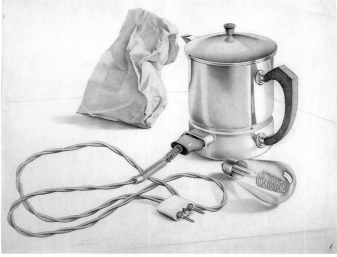

15

16

"snatching the real from the principle of reality. snatching the image from the principle of representation."

Jean Baudrillard

tography played a major role in Francis Bacon's painting technique – but a quite different role from the one it played for the Photo-realists. Bacon's perception of the world was determined by photographs, a glance into his studio revealed a veritable flood of pictures, an abundance of photographs and reproductions, most of them creased or soiled, a kind of "compost heap", as Bacon himself called it, a hotbed of pictorial ideas. Bacon's confrontation with reproductions of Velázquez' portrait of Pope Innocent X, dating from 1650 (ill. 13) has led to numerous results. The picture can be seen along with Nadar's photograph of Baudelaire, and pictures of top Nazis like Himmler and Goebbels, on a photograph of his studio wall (ill. 12).

The pope, depicted realistically and not very flatteringly, is traditionally said to have described his portrait as "troppo vero" (too honest), and if one were looking for proof of painting's anti-idealistic potential, this would be an excellent example. Bacon was obsessed by this picture, and yet he never saw the original, not even during a lengthy stay in Rome. When he was asked about this, he said, no, he was not interested in the original, but conceded that another reason might have been "a fear of seeing the reality of the Velázquez after my tampering with it". His 1953 study based on the Velázquez picture fuses the papal portrait with the face of the screaming woman on the steps of Odessa in Eisenstein's film *The Battleship Potemkin*, and

this amalgam is characteristic of a procedure which seeks to create no superficial likeness, but rather to plumb the secret of human appearance.

This transformation results in pictures that have nothing to do with "art colour photography", as Bacon described academic portrait-painting. The condition is "inter-pictoriality" on the basis of a wide variety of photographic material that serves the intensification of expression.

photographic realism

Quite apart from its fundamental importance for the realistic painting of the 20th century, how are things looking for photography as an autonomous artistic medium? Albert Renger-Patzsch, the avant-garde photographer of the 1920s and early 1930s, answered this question in 1927 as follows: "The secret of a good photograph, which can have artistic qualities just like a work of the visual arts, lies in its realism."

With these words, Renger-Patzsch asserted the autonomy of photography and pointed to his own object-related technique. Like August Sander in the field of portrait photography with his systematic

1937 — "Degenerate Art" exhibition in Munich
1938 — Radio drama "The War of the Worlds" by Orson Welles triggers mass panic on America's east coast

THE AMERICANS

PHOTOGRAPHS BY ROBERT FRANK
Introduction by Jack Kerouac

17

encompassing of German people, and Karl Blossfeldt with his objective photographs of plants, Renger-Patzsch made his own name by photographing objects. With its almost clinical view of the world of objects, his most important publication "Die Welt ist schön" (The World is Beautiful; ill. 14), which appeared in 1928 and was originally intended to bear the title "Die Dinge" (Things) and thus accord with the unpretentious attitude of the "New Vision", fits well into an era that included the transformation brought about by the invention of the electric light, and which Virginia Woolf accurately described in her novel "Orlando": "Vegetables were less fertile; families were much smaller. Curtains and covers had been frizzled up and the walls were bare, so that new brilliantly coloured pictures of real things like streets, umbrellas, apples, were hung in frames or painted upon the wood." Orlando made this observation on October 11, 1928.

The similarities in the pictorial languages of painting and photography in the 1920s were striking. Correspondences can be found for example in the photograph *Electric Light-bulb* (*Elektrische Birne;* ill. 15), likewise dating from 1928, by Hans Finsler, an important exponent of Neue Sachlichkeit, and Rudolf Dischinger's 1931 *Electric Cooker* (*Elektrokocher;* ill. 16). The "aggressiveness of precise reproduction, if possible down to the smallest details," according to

Dischinger an essential characteristic of this style, is present in photography at least as strongly as in painting. Emphasizing the linearity, illumination brings out the material and surface qualities of the bulb and its socket.

The same trust in the expressiveness of the visible was evinced by the American exponents of Straight Photography, who, likewise in opposition to Pictorialism (which was directed to producing a scenic effect), turned to an untouched-up, "media-appropriate" photography. One of their earliest representatives, Alfred Stieglitz, said in the early 1920s: "There is nothing in my photographs that isn't there – that doesn't originate directly from the photographic object." The group of modern American photographers included, alongside Paul Strand, Charles Sheeler, who also paid attention to the possible uses of photography when creating his paintings, and, with his industrial scenes and pictures of machines, became a Photo-realist *avant la lettre*.

But over and beyond these strictly object-related styles, the 20th century saw the establishment of strategies with a different, politico-educational agenda. These too can be called "realistic". In this connexion, the most important publicly initiated project was the documentation of the tribulations of the rural population in the Mid West of the United States, commissioned by the Farm Security Administration (FSA) between 1937 and 1942. The programme gave rise to icons of

1942 — The "Wannsee Conference" discusses the organisation of the systematic extermination of the Jews
1945 — Atomic bombs dropped on Hiroshima and Nagasaki

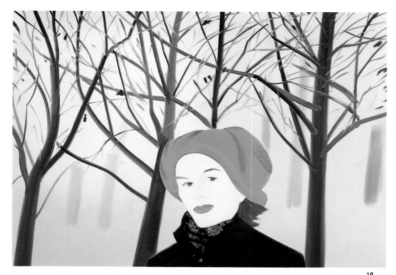

18

19

"my work is aimed at creating a world in which I wish to live. consequently, it is about creating ideals with the aid of realistic techniques."

Wolfgang Tillmans

20th-century photography, such as Dorothea Lange's *Migrant Mother*; altogether, these pictures constitute an archive of more than 77,000 black-and-white photographs and some 1,600 colour pictures, which is now housed in the Library of Congress.

In the years to follow, another photographer who worked for the FSA project, Walker Evans, created legendary documents of the age in his "documentary style". He it was who immediately recognized the quality of the work of Robert Frank, alongside William Eggleston perhaps the most important artist to have put his stamp on the photographic confrontation with reality in the 20th century. Born in Switzerland, Robert Frank undertook a journey to the United States in the 1950s and came up with every conceivable view and detail, a visual study of a civilization which undermined the positive image of America. The resulting book "The Americans" (ill. 17), with its filmic structure and closeness to reality, became a milestone of photographic literature. In the preface, Jack Kerouac wrote: "To Robert Frank I now give this message: You got eyes."

As for William Eggleston, since the 1970s he has been one of the most important photographers working in colour. Most of his photographs come across as more real than pictures are normally thought capable of being. Against the trend of fleeting consumption of visual impressions, they positively demand a second and third look. The world may not be beautiful, but Eggleston's austere subjective eye teaches us to accept it as it is.

There are currently numerous projects which seem to express a periodically recurring need to question reality. Well-known in this connexion, for example, is the Russian photographer Boris Mikhailov with his merciless social reportage. But while dealing with the subject of Realism, it would not be enough to take account only of "classical" documentation or at least of work in the documentary style. There are staged photographs which can equally make statements about reality, and in principle, part of the importance of analogue photography continues to be that it provides a hint of the real.

The fragmentary seems to have become an important criterion recently; personal experiences, which go to produce an atmosphere, a mood, have escaped from the sub-culture since the exhibitionist photographs of Nan Goldin. In the case of Wolfgang Tillmans (ill. 19; b. 1968), the specific picture of a particular youth culture likewise plays a decisive role. His "anti-aesthetic", which has been on view since the early 1990s in magazines, catalogues and exhibitions, finding many imitators, is seen as the expression of a complex search for evidence. The casual manner of presentation, which sees transience as proof of authenticity, is also effective in the exhibition context.

1945 — Churchill, Roosevelt and Stalin decide at Yalta to divide Germany into occupation zones

1946 — European artists begin to return from exile 1947 — End of colonial rule: India gains independence

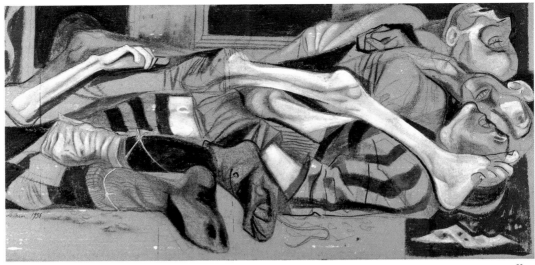

Reproduction of reality as education?

The important role that photography now plays in the artistic context has changed its function. We can agree with the photographer and photo-theoretician Allan Sekula in describing the sociological appropriation of photography as instrumental Realism – early anthropological, criminological and psychiatric photography, along with movement studies, was all part of an experiment to link optical empiricism with abstract truth. For a time, there was also widespread hope that people would understand the monstrous nature of war once its horrors were displayed graphically enough to them. It was in this spirit that the pacifist Ernst Friedrich published his book "Krieg dem Kriege" (War on War) in 1924, using 180 pictures of devastation, prostitutes in military brothels, starving children, dead soldiers, and – in the chapter "Das Gesicht des Krieges" (The Face of War) – 24 close-ups of soldiers with horrifically disfiguring facial injuries, in order to make a passionate call for a war on war. Welcomed by numerous intellectuals, artists and writers, the book had gone through ten editions by 1930, but it was no more able to prevent the next war than were the drastic watercolours of the wounded which Otto Dix painted on the basis of Friedrich's originals, or his anti-war painting *The Trench*, dating from 1924. The pictures of the other so-called Verists on the left wing of

Neue Sachlichkeit, such as George Grosz and Rudolf Schlichter, who used provocative motifs in order to capture the post-war period, also raise the question of intended and actual effect. *Maimed Working-Class Woman*, dating from c. 1926, is, together with drawings like *Worker with Cap* or *Unemployed Man*, a picture from Schlichter's *Gallery of the Nameless*, which was created in parallel with his famous portraits of the 1920s – for example of Bertolt Brecht. With precision, and with less distortion than Grosz, Schlichter captures the feelings of women, and we may presume that this was how the then card-carrying Communist intended to express his critical social commitment.

Some themes raise the fundamental question of whether, and if so through what medium, reality can be appropriately reproduced. Thus there exists a photograph of Buchenwald concentration camp which was taken by Lee Miller shortly after its liberation. She was one of the first to be given a photography permit, and she photographed a pile of corpses, cropping it in such a way that one can realize that it is very much larger than we see on the photo. In the 1950s the painter Rico Lebrun (1900–1964) published his Buchenwald series (ill. 20), undertaking compositional "improvements" with the aim of dramatization: the pile of corpses comes across as staged, and there is nothing to suggest that we only have a detail; the dead are somewhat rounded, and the stones on the ground can no longer be made out. In

1948 — Mahatma Gandhi assassinated 1949 — George Orwell writes science-fiction novel "Nineteen Eighty-four"
1952 — Coronation of Queen Elizabeth II of England

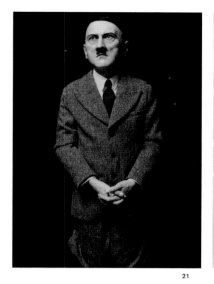

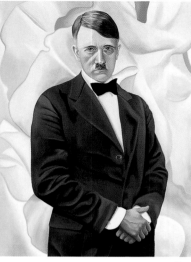

21

22

20. RICO LEBRUN

<u>Floor of Buchenwald No. 1</u>
1957, charcoal, ink and casein on Celotex,
122 x 244 cm
New York, The Jewish Museum,
Gift of Constance Lebrun Crown

21. MAURIZIO CATTELAN

<u>Him</u>
2001, wax, human hair, suit, polyester resin,
101 x 41 x 53 cm
Private collection

22. IRENE VON NEUENDORFF

<u>Portrait of Hitler</u>
2000, oil on canvas, 120 x 90 cm
Courtesy Galerie Rainer Wehr, Stuttgart

"тo be defeated, power must be approached, reapproriated and endlessly replicated."

Maurizio Cattelan

his standard work *The Painter and the Photograph*, Van Deren Coke had this to say about him: "He has in fact become blind not to the photograph merely, but to reality. The photographer was not blind. However passive the camera, the photographer chose this 'detail', this angle, this exposure… The photographer has seen, and shows us, Buchenwald. The painter shows us only a painting."

Gerhard Richter's *Atlas*, a comprehensive storehouse of our mass-media visual culture, consisting of more than 500 plates and more than 4,000 individual pictures, contains – alongside banal family photos and landscapes – photographs of concentration-camp inmates, which are presented in the immediate vicinity of pornographic photographs. After a number of experiments with out-of-focus or garishly coloured pictures, Richter finally admitted that the horror of Auschwitz was not capable of realistic depiction. The artistic ambition of aestheticization through the medium of painting seems to be impossible in the face of this subject-matter.

Invented horrors can overwhelm the beholder, but as Susan Sontag notes in "Regarding the Pain of Others", à propos of Hendrick Goltzius' (1558–1617) copperplate engraving *The Dragon Devours the Companions of Cadmus*, in which a man is having his face bitten off, it is quite different to shudder at this than at the sight of a photograph of a veteran of the First World War, half of whose face has been

shot off. There are, however, present-day examples, for example Richter's cycle dealing with the dead prisoners in Stammheim gaol (members of the Baader-Meinhof terrorist group), or Leon Golub's pictures of violence, which function as comments on how we deal with photographs and can serve as examples of a considered way of coping with depictions of horror.

Photographs in stone

In the sphere of sculpture, too, there are relationships with photography; many 20th-century sculptures can reasonably be described in terms of Photo-realism. When Auguste Rodin in 1877 introduced his sculpture *The Vanquished* to the public, one critic declared that it had been cast from a living model. Decades later, Rodin still had not overcome this attack on his demiurgic abilities. In 1914 he wrote in *Les Cathédrales de la France*: "In sculpture, the plaster cast, this cancerous wound of art, runs wild after nature." And yet at the same time, in the foundation myth of Western sculpture, the story of Pygmalion, who fell so hopelessly in love with the statue of Galatea which he had himself carved – proof if any were needed that it must indeed have been lifelike – Venus was moved to awaken her to life. "Lifelike" how-

1953 — Alfred Kinsey publishes his report on "Sexual Behaviour in the Human Female"

1953 — Death of Stalin

1953 — Premiere of Samuel Beckett's play "Waiting for Godot"

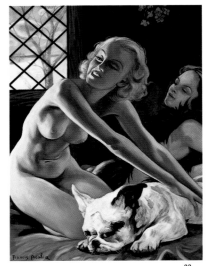
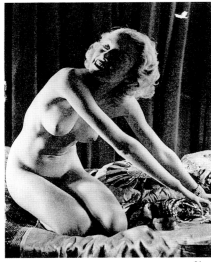

23 24

"our heads are round so our thoughts can fly in any direction."

Francis Picabia

ever has often been a negative assessment; a famous example is Charles Baudelaire's essay entitled "Why sculpture is boring", in which he attacks "brutal and positive" sculpture.

Duane Hanson found himself subjected to the same criticism with his own lifelike statues, although it must be added that he had no problem with casts and also used available clothing. When necessary restoration work was needed, he even aged some of his figures, as though we did not already have the story of the stonemason who is said to have created such a good likeness of the Emperor Rudolph von Habsburg that he even remembered the wrinkles in his face. A few years later the artist updated the statue by adding a few more. Gustav Theodor Fechner uses this story in his "Vorschule der Ästhetik" (Primer of Aesthetics) as an example of how Realism should *not* be understood; the work of this sculptor, he said, was no "true work of art", but a "photograph in stone". In this sense, the equation of "lifelike" with "inartistic" is an old problem for Realism. And it goes without saying that artistic *trompe l'œil* is not what 20th-century Realism is interested in. Hanson is concerned to depict the inner state of the person depicted, just like Ron Mueck, whose subtle capture of emotional states, while altering the original scale of the depicted subject, can be seen as a successful innovation in the sector of contemporary reproduction of reality.

In the sphere of sculpture, there are some works with a realistic touch which can only be described as kitsch. The best-known example is Jeff Koons with his integration of "low" art into the sphere of so-called high art, a Realist who parades our own lack of taste before our eyes. Nothing is any longer safe from irony: the best-known example from recent times being perhaps Maurizio Cattelan's (b. 1960) *Him* (ill. 21), dating from 2001, a kneeling, smaller-than-lifesize Hitler, which he places in one corner of the exhibition room. In view of the uniform steeled bodies of Nazi and socialist artists, this unheroic pose can also be seen as a comment on established forms of representation. There was no specifically Nazi sculpture: no portrait statues of Hitler ever existed, but instead, the male nude was depicted time and again.

In painting, too, sensitive subjects also crop up: Irene von Neuendorff (b. 1959) in her *Hitler* series (ill. 22) reminds us on the one hand of a particular kind of stylization and self-staging, such as we see in contemporary photographs and portraits, while at the same time she uses clothing – the casually open jacket – and the background of quasi-erotic flower-paintings, which recall the pictures by Georgia O'Keeffe, to call attention to Hitler's role as "seducer". This provocation does not serve some diffuse mythologization of the Nazi system, but neither does it give any hint of Hitler's crimes. Rather, the picture seems to be a commentary on the "banality of evil" and maybe

1954 — The first world exhibition of contemporary art, documenta 1, in Kassel
1956 — Founding of Pop Art in London 1960 — Pierre Restany "invents" the art movement Nouveau Réalisme

"Every artist is a person."

Martin Kippenberger

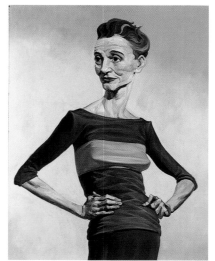

25

26

on Hitler's own artistic endeavours and the depressing art policy pursued by the Third Reich. Ironic strategies have now even gained in importance when it comes to Realistic painting.

Realism and irony

The history of modern art has undergone some revision, and a painterly confrontation with reality seems to be respectable once more. But is not realistic painting reactionary, as was supposed during the years of enthusiasm for Abstraction? If we consider one of the most recent exhibitions on the theme, "'Dear painter, paint me…' – Radical Realism after Picabia" we might get the impression that the integration of kitsch elements was a decisive criterion for seeing the world in a realistic light.

The exhibition figurehead, Francis Picabia (1897–1953), was represented with works from the post-war period. His *Femmes au bulldog* (ill. 23) is an example of what at first sight comes across as an eclectic style of painting: the originals are taken from erotic magazines of the 1930s (ill. 24) – yet another proof that photography has become an integral component of painterly production. But Picabia transformed the pictures: the decorative items of the original have

been replaced by a dog, while a second woman has been added – in accordance with his poetics, which he defined in 1921: "The painter chooses something, then he imitates what he has chosen, and finally deforms it. This last is where the art lies." This could almost have been written to describe John Currin (b. 1962), whose realistic grotesques, for example the picture of de-sexualized middle-aged women, use forced ugliness to dissect various clichés (ill. 25). In this he is moving in a tradition in which European-American parallels can be noted: one might think of the pictures of the decay of the human body by Otto Dix, old-masterly in their technique, revolting in their exaggeration; the artist was described by Carl Einstein in his "Kunst des 20. Jahrhunderts" (Art of the Twentieth Century), published in 1926, as a "painting reactionary, employing left-wing motifs". Or we might think of Ivan Albright, whose morbid figures are just as excessively modelled. Only in passing do we mention that Currin too has adapted originals taken from men's magazines.

The importance of irony can be seen clearly enough in the works of one of the best-known exponents of so-called Kitsch Art, Milan Kunc, who, as a self-styled representative of "Embarrassing Realism" placed himself in a victorious youthful pose in front of a propaganda poster. Martin Kippenberger's (1953–1997) *Pleasant Communist Girl* (ill. 26), in which the snapshot aesthetic of the pic-

1960 — Contraceptive pill goes on market in America

1961 — Berlin Wall erected

1963 — John F. Kennedy assassinated in Dallas

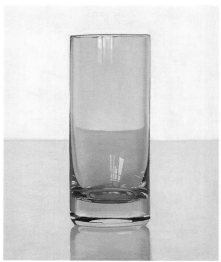

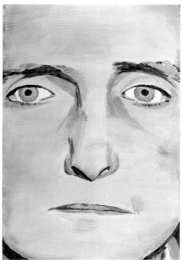

27 28

ture points to possible originals on which it might have been based, functions as a game with set-pieces of Socialist Realism. The likeable woman in question is giving the beholder a shy, pleasant smile while wearing her uniform and cap with its red star. Against the de-individualization which was one feature of the depiction of the "new man" (or woman) in the official state art, Kippenberger thus pits the private aspect.

As an explanation for the continuing artistic concern with Socialist Realism, we might do worse than to quote Ilya Kabakov's observation: "Socialist Realism is for me a dead style, which fasci-nates me aesthetically and as a human being and so on, but which basically I would have absolutely no trouble in doing without. The fact that I make use of it is a puzzle even to me. I feel as if I had fallen into a muddy pool, have never been able to wash the dirt off, and so have to carry it around all the time."

seeing is believing

The thesis that major Realist artists are individualists after all is not entirely without support, however. Peter Dreher (b. 1932) is a master of perseverance. In 1972, he painted the first of a long series of pictures of an empty glass standing on a plain surface against the background of a wall. Every year since, he has painted between 50 and 80 pictures, reflecting the perception of the real in changing con-ditions. The early pictures were done in uniform artificial light, but since 1974 he has used natural daylight. The depiction within the pre-determined 25 x 20 centimetre format corresponds to the real size of the glass. In the daylight pictures (ill. 27) we can see the studio win-dow reflected in the glass, which as it were concentrates the bare interior of the room. The individuality of each picture is due to chang-ing external and internal influences, to the different moods of the artist, who has in the meantime grown older by thirty years, and to the different climatic conditions in the little mountain health resort in the Black Forest where his studio is situated. Dreher, who stands at what is currently the end of the line linking Chardin with Morandi, is the sole exponent of Zen Realism.

Dreher was at the Karlsruhe Academy from 1950 to 1956, studying under Karl Hubbuch and Wilhelm Schnarrenberger among others, and came thus under the influence of the late-Neue Sach-lichkeit description of things, as pursued by those artists who in the 1920s enjoyed success at the "Neue Sachlichkeit" exhibition in Mannheim. After the Second World War they met with no broad acceptance in the West at first, but figurative art has long since found

1964 — Black civil-rights leader Martin Luther King awarded Nobel Peace Prize
1969 — American astronaut Neil Armstrong becomes first man to walk on moon

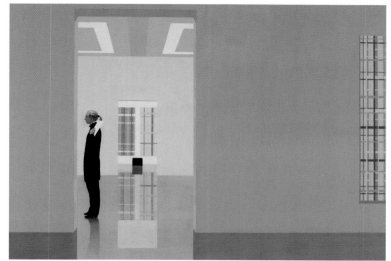

27. PETER DREHER

<u>Day by Day is Good Day</u>
1997, oil on canvas, glass no. 1502, 25 x 20 cm
Courtesy Galerie S 65, Cologne

28. LUC TUYMANS

<u>The Diagnostic View IV</u>
1992, oil on canvas, 57 x 38 cm
Private collection

29. TIM EITEL

<u>Museum Educationist</u>
2002, oil and acrylic on canvas, 110 x 140 cm
Courtesy Galerie EIGEN+ART, Leipzig/Berlin

its way back to respectability once more, and in contemporary painting there are many styles which do not deny their roots and evince a truly original approach to reality.

Luc Tuymans' (b. 1958) series *The Diagnostic View* is further evidence of an innovative approach to the use of existing pictorial material. Pictures like *The Diagnostic View IV*, dating from 1992 (ill. 28), are based on illustrations in a manual of that name, which contained illustrative material to assist in the recognition and correct identification of illnesses. No symptoms of particular illnesses can be discerned, the diagnostic eye is concerned with depersonalized faces and body-parts. Tuymans was concerned, "to see that the search for an encounter with the real should end in failure".

We can agree with Leon Golub, who captures repellent human dispositions like no other, in recognizing the basic relationship with reality without getting entangled in difficulties of definition: "I didn't say that, necessarily, this is realism, but I did want to get at the real." The hope of changing the world through art has shown itself often enough to be utopian, but Jeff Wall, who, with his staged photographs seeks to reproduce social reality and lead us to a reflective receptive attitude, has come up with the maxim that while looking at art may not change the world, it can change the beholder and his or her relationship with the world.

Painting can be self-reflective and realistic without denying the avant-garde developments of the last century. *Museum Educationist* by Tim Eitel (b. 1971), dating from 2002 (ill. 29), is a good example. In Eitel's pictures, realistically depicted people move with recognizable poses and familiar gestures in confined areas. The museum educationist, with a sheet of paper in her hand, and facing a picture which – unlike three others – is invisible to us, seems to be thinking about how she can explain abstract art to her clientele. The pictures look like Imi Knoebel's monumental panels in their cheerful artificial colours.

Even at the end of the modernist era, figurative painting is still possible, and we can often see how undogmatically realistic positions are put forward. What continues to be important is the curiosity to experience art and reality. For, as John Berger has said: "What we can see has always been and continues to be the main source of our knowledge of the world. We take our bearings from what we can see." Even today, we need pictures to make a picture of the world.

--

1970 — Whitney Museum of American Art stages "22 Realists" exhibition

1972 — Terrorist attack on Israeli athletes at Munich Olympics **1974 — Muhammad Ali defeats George Foreman in Kinshasa**

--

accumulation of Jugs

Enamel jugs in Plexiglas cabinet, 83 x 142 x 42 cm
Cologne, Museum Ludwig

b. 1928 in Nice

While Yves Klein, especially in the exhibition "Le Vide", liberated himself from the everyday world of objects by fêting the immaterial in order to celebrate artistic freedom, Arman has devoted his work to abundance. The stage was set by his 1960 exhibition "Le Plein" in the Iris Clert gallery in Paris, to which he transported a lorry-load of objects of diverse origin, and unloaded them, so that visitors could only see a great heap of rubbish through the gallery window. Born Armand Pierre Fernandez, Arman studied at the renowned École du Louvre and went on to co-found the Nouveaux Réalistes, becoming a leading figure in the group, whose members were united not by any particular style, but by the desire for radical gestures. After going to New York in 1963, Arman also had a decisive influence on the parallel American New Realism movement.

Since 1959 he has been regarded as the chief exponent of the "Accumulation", an intensified form of the relief-like Assemblage, consisting precisely of an accumulation of various objects, which are mostly locked away behind Plexiglas. Arman's excessive Accumulations – the principle of which, by his own account he did not discover, but which rather discovered him – are collections of articles taken from everyday life which were at first intentionally random; thus Arman once cast the contents of a dustbin in artificial resin, thereby achieving an effect reminiscent of Kurt Schwitters' Dadaist collages.

Later the objects used were carefully chosen: thus in addition to collections of small cog-wheels we have this *Accumulation of Jugs,* assembled in 1961, of metal jugs enamelled in various ways. They bear traces of use, and each is unique by dint of its colour, degree of wear and tear, and personal history. Those who buy individual items like these at flea-markets know they are buying, along with each item itself, its past. It then as a rule serves as a decorative flower-vase or becomes part of a personal arrangement of private objects and no longer fulfils its original function. As the son of an antique-dealer, incidentally, Arman spent much of his childhood at flea-markets, and the concept of the "Accumulation" was familiar to him, his grandmother filling cardboard boxes with corks and bits of string, and carefully labelling them accordingly. In Arman's seemingly chaotic Accumulation, the jugs become symbols of the throw-away society and can be seen as a commentary on consumer behaviour. With the proviso that Arman's numerous objects follow no commercial logic, they are reminiscent of department-store displays, where ensembles of similar objects are offered for sale.

The graphic image of a world being submerged in garbage links this and other Accumulations with the "Compressions" of the French artist César, who, for example, has had car-bodies compressed into stele-like blocks. Thanks to the transparent showcase and the recognizability of the objects, Arman however succeeds in providing very much more direct access to the reality of our lives, and we can begin to understand why the artist refers to his objects as "humanized". Arman seems not to have questioned the clue that the mentor of the Nouveaux Réalistes, Pierre Restany, gave to the sociological dimension of his works. By thematizing the concept of mass production in a society already characterized by super-abundance, Arman has – aesthetically – taken a stance on a familiar phenomenon.

"I am a witness to my own epoch."

Arman

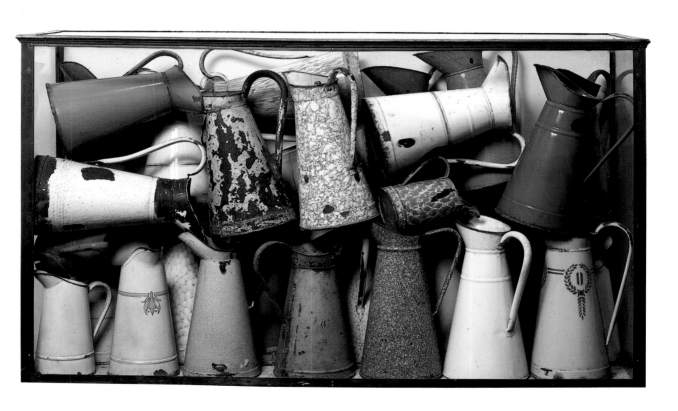

La toilette de cathy

Oil on canvas, 165 x 150 cm
Paris, Musée National d'Art Moderne, Centre Pompidou

**b. 1908 in Paris,
d. 2001 in Rossinière**

Balthazar Klossowski de Rola was born as the second son of the art-historian and painter Erich Klossowski and the painter Elisabeth Dorothea Spiro, alias Baladine Klossowska, and he continued to assert lifelong that he had never ceased to see with the eyes of a child. Balthus himself was opposed to any interpretation of his pictures. He wanted them to be understood as still-lifes, and cheerfully admitted that his painting was concerned with a world that was no longer valid today. When he was ten years old, he made a series of pen-and-ink drawings of a cat which had first adopted him and then run away again, published in an album by his friend and mentor Rainer Maria Rilke. From then on he created an œuvre, limited both in its style and its motifs, whose declared aim was beauty.

The painting *La toilette de Cathy*, dating from 1933, is based on an early episode in Emily Brontë's 1847 novel *Wuthering Heights*. As a teenager, Balthus lived for a time with friends in Yorkshire, where he discovered the untamed landscape in which this story is set. In Balthus' adaptation of the scene, there is little trace of the atmosphere of gothic romance which pervades the literary original, nor of certain details: the painting depicts Cathy, in a wide-open dressing-gown, assisted by her maid Nelly, preparing for an assignation with her admirer Edgar Linton. In the corresponding scene in the novel, Heathcliff, who loves her more than anything else in the world, just happens to be passing after emerging from the stable, but here is depicted by Balthus in elegant clothing. He comes across as tense, seems however not to be calling her to account, but rather makes a withdrawn impression.

This is in marked contrast to an Indian-ink illustration of the same motif, in which Balthus depicts Cathy as fully clothed and Heathcliff as turning towards her and her maid with a black look on his face. Balthus explains: "I don't know whether I portrayed myself with Heathcliff's features, but when I look at the drawings today, I see traces of my former rebelliousness." That Balthus identified with Heathcliff's rebellion against society is confirmed by the way in which he portrayed the character with his own facial features and depicted him in a pose similar to that in which he himself was portrayed by the photographer Man Ray that same year. Cathy by contrast comes across as other-worldly, somewhat wooden in the manner of a Cranach picture, and, as usual with Balthus, has too large a head – Antonin Artaud has described these proportions as those of people with water on the brain. She bears the features of his future wife Antoinette de Watteville, and her pale skin provides a nice contrast with Heathcliff's swarthy complexion.

Balthus never attended an academy, orienting himself by exemplars whom he chose himself, such as Piero della Francesca; as a result, he did not succumb to the eclectic neo-Classicism of the 1920s and 1930s. In the matter of both form and colour, Balthus came to master expressive qualities reminiscent of frescoes. Allegedly he was never able to understand the uproar he caused with his naked nymphets like Cathy, since he always regarded his works as depictions of innocence. His "dear little angels" look like frozen statues, and in his later years became mere stage-props. But in *La toilette de Cathy* we can still feel the aura of demonic tension which made Balthus the inimitable master of those passions which are both secret and real.

"one can be a realist of the unreal and figurative with regard to the invisible."

Balthus

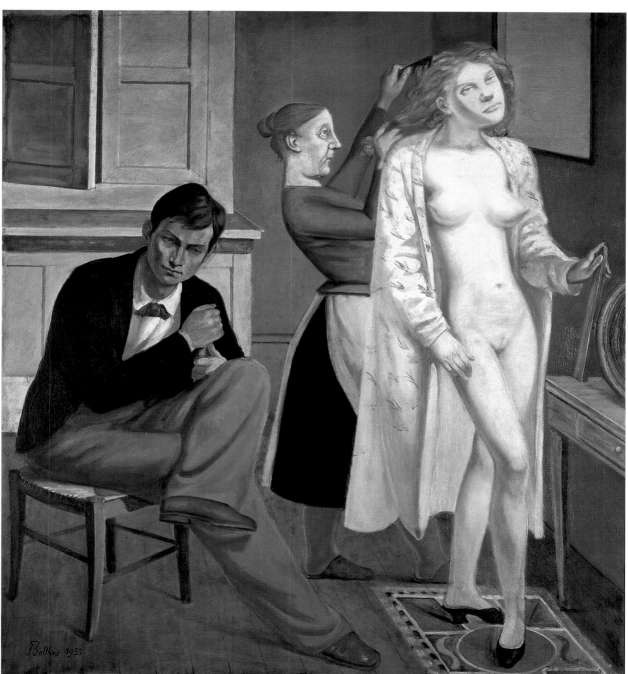

COMMUNITY LIBRARIES

self-portrait in Dinner-jacket

Oil on canvas, 141 x 96 cm
Cambridge, Busch-Reisinger Museum, Harvard University

b. 1884 in Leipzig,
d. 1950 in New York

Max Beckmann spent part of World War I as an ambulance-man. The experience resulted in mercilessly realistic drawings of the wounded, dead and dying. His meticulous observations doubtless led to his subsequent nervous breakdown. In his self-portraits he dissects his own state of mind. One of the best-known, the 1927 *Self-portrait in Dinner-jacket*, clearly depicts someone who has seen a great deal. What we see is a man coming across as self-confident to the point of arrogance with a pronounced, almost bald crown, one hand resting on his hip, and in the other, which is spread in a somewhat mannered fashion, the almost inevitable cigarette, which, along with the elegant black-and-white contrast of dinner-jacket and shirt, gives him an urbane air: in the 1920s, the dinner-jacket in advertising and portrait photography had become the symbol of big-city life. The picture background is divided into whitish-grey and black sections; on the left, a door-frame can be seen, which delimits the darkness of a room: the white wall towards the right is repeated in the white of the shirt, the black of the dinner-jacket is taken up by the darkness of the room next door.

The size of the figure is emphasized by the austerely frontal view seen marginally from below eye-level, but what comes across as a result is not pure artistic vanity, but merciless self-questioning: the shadows which form the statuesque face bathe the forehead, nose, chin and one eye in darkness, while the light areas recede to the point where we can share Reinhard Spieler's impression that we are "looking directly into the interior of his head, as though the dominant head would turn out unexpectedly to be a hollow death's head." Certainly the form taken by the illumination, which divides the face down the middle, creates a tear or crack which seems to be continued down through the mid-line of the body to the slightly parted legs.

This sinister apprehension which has settled on his face may be the expression of Beckmann's experiences and his realistic assessment of coming political developments. By radically simplifying the shapes and drawing sharp contours, Beckmann in this picture and his entire œuvre captures the magical element of reality and translates it into painting, which comes across as more monolithic and at the same time more insistent than any precise reproduction. Beckmann links the choice of the dinner-jacket as the costume for this painting with a utopia such as he described in the same year as the painting in an article entitled "Der Künstler im Staat" (The Artist in the State): "The new priests of these new cultural centres have to appear in dark suits, or, on ceremonial occasions, in white tie and tails, if we do not succeed in inventing a more precise and more elegant form of masculine attire. Furthermore, it is essential that working men too should appear in black tie or white. In other words, we hope for a kind of aristocratic bolshevism. A social compensation, the basic idea behind which, however, is not the satisfaction of pure materialism, but the conscious and organized urge to become God oneself." Beckmann's stylization seems to be evidence of an exaggerated feeling of self-esteem, which arose out of decadence and despair, and still disturbs us modern beholders because the representative character of the picture is contradicted by its evidently cryptic nature.

"If you want to grasp the invisible you must penetrate as deep into the visible as possible."

Max Beckmann

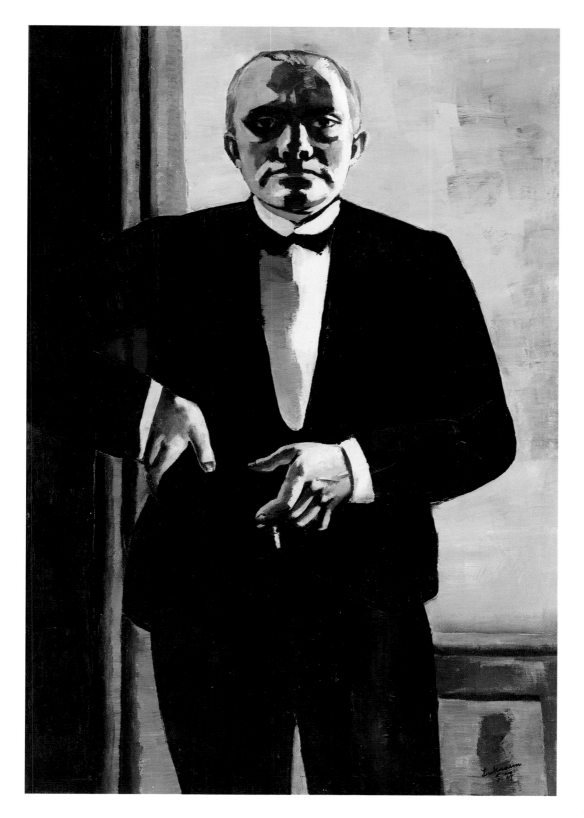

gumball xv

Oil on canvas, 226 x 155 cm
Courtesy Louis K. Meisel Gallery, New York

"my paintings look real, but it's a subjective reality."

Charles Bell

**b. 1935 in Tulsa (OK),
d. 1996 in New York**

The *Gumballs* by Charles Bell, which have appeared in the years since 1973, are, together with his *Pinballs* and the pictures of marbles or old tinplate toys, among the best-known Photorealist still-lifes. *Gumball XV*, dating from 1983, is painted with great precision: the red paint of the vending machine is flaking off in many places, while the beholder can almost hear the coins rattling over the metal. But the content is glossy and seductive: balls of chewing gum, and charms such as a miniature lock, a green plastic elephant or a little mirror – the casual integration of a traditional symbol of *vanitas,* itself a play on the double meaning of the word "vain", referring also to transience of earthly things – and above all two of the famous chewing-gum-vending-machine rings, for the acquisition of which countless little girls have invested a great deal of pocket-money and chewed a great deal of stale gum.

The seductive power of the picture, which appeals to the haptic memories and gustatory experiences of childhood, is based on the re-creation of a photograph, as always one taken by the artist himself. Copy Berg described in graphic terms the meticulous arrangements made by Bell prior to every photograph: "I have seen Charles, before ever taking a photograph, spend hours under hot lights, placing charms und gumballs in various combinations inside a machine."

True, the motif is not new in American art. Wayne Thiebaud, who saw himself as a Realist, not a Pop Artist, painted a *Jawbreaker Machine (Bubblegum Machine)* in 1963: the same colourful, frontal view of a chewing-gum dispensing machine. Here, though, the depicted object is graphically reduced and placed in front of a neutral background. No one painted reflections with such an enduring fondness for repeating motifs as did Bell – as in the adjacent picture, mostly supplemented with a cut-off section of a peanut-dispenser and a jar of lollipops.

Audrey Flack (b. 1931) is similarly in love with surfaces. Her *Strawberry Tart Supreme*, dating from 1974, is comparably smooth: what we see are five pieces of cake, the cream-crowned strawberry tart in the centre, surrounded by cream slices, a meringue and chocolate bicuits. The lushness of what is depicted is emphasized by the fact that these things are standing on a silver tray in front of a mirror. In Flack's picture, as in Bell's, the things depicted are not the expression of a religious or secular symbolic language: chewing-gum remains chewing-gum, and a strawberry tart remains a strawberry tart.

The meticulous way in which objects are captured by the Photorealists, which is what Bell's patron, the gallery-owner Louis K. Meisel so admired about them, seems to be the central quality of this and other pictures: "Bell remained among the few artists anywhere who adhered to traditional standards of quality in art."

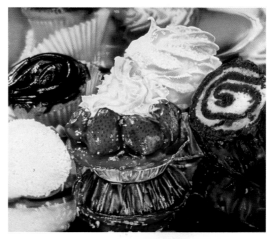

Audrey Flack, Strawberry Tart Supreme, 1974

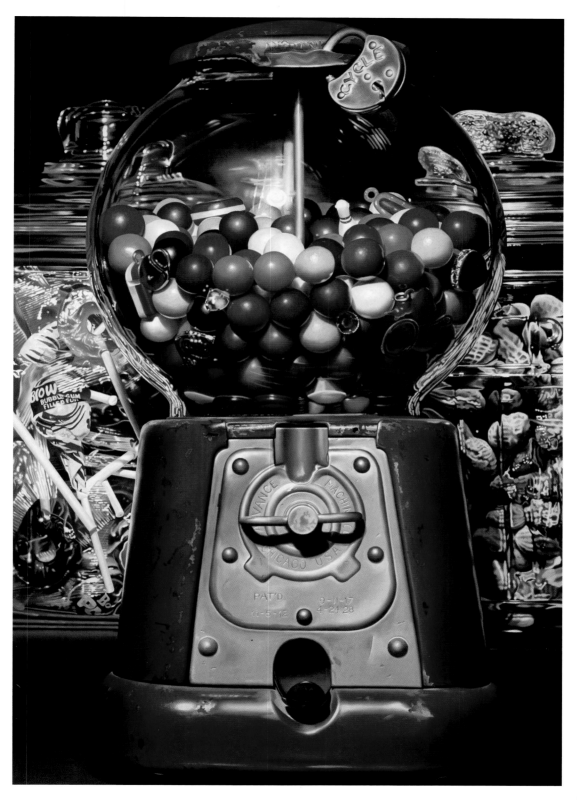

Equisetum hyemale
Equisetum telemateia
Equisetum hyemale

Common horsetail, 12fold enlargement
Giant horsetail, 4fold enlargement
Common horsetail, 18fold enlargement
Photograph, 36.6 x 27.8 cm
Zülpich, Karl Blossfeldt-Archiv – Ann und Jürgen Wilde

**b. 1865 in Schielo (Harz),
d. 1932 in Berlin**

Karl Blossfeldt was an exponent of Neue Sachlichkeit *avant la lettre*. A sculptor by training, when he was appointed to a post at the Königliches Kunstgewerbemuseum Berlin in 1898 to teach "modelling plants from life", he started to collect plants and flowers which he would prepare in his studio before photographing them against a neutral background. When his "Urformen der Kunst" (Basic Forms of Art) appeared in 1928, this self-taught photographer became famous in a quite different area from that of applied object-photography for teaching purposes. In his history of photography, Helmut Gernsheim wrote: "Neue Sachlichkeit had its breakthrough with the publication of Karl Blossfeldt's *Urformen der Kunst* in 1929." Blossfeldt lived to see this recognition, though not the many reprints of his book in the years to come.

The three photographs of horsetails are prime examples of austere image construction. This plant, actually a living fossil which first appeared 400 million years ago, has no leaves or flowers, but consists purely of a system of stalks that comes across as an abstract and formal construction. Rough, with flat ribs, the linked stalks are reminiscent of architecture: in Werner Lindner's book on technological buildings, these pictures by Blossfeldt serve as the unsurpassed basic type of longitudinal extension, and are regarded as the expression of a continuity which extends from towers in ancient China to contemporary skyscrapers. And in fact Blossfeldt was concerned not only to create teaching aids, but also to trace archetypes and to depict a plant's "artistic-architectural" structure.

Blossfeldt's unpretentious photography, its reductionist aesthetic with all its association-creating possibilities, fulfils many of the criteria of Neue Sachlichkeit's way of looking at the world and at things: extreme close-up, for example, with up to 18fold enlargement, and emphasizing of abstract structures through the isolation of details. The documentary agenda gives rise to a pictorial composition which may possibly have influenced the execution of painted plant motifs by such Neue Sachlichkeit painters as Rudolf Dischinger or Fritz Burmann. Quite certainly it can be seen as a prime example of the objectivization tendencies, which began to come into their own following the aestheticization of the photographic medium in the late 19th century into so-called "art photography" which sought to imitate painting.

It must be remembered, however, that while the details are exact, they are taken out of their context, and that the uniform grey background provides no information on the plants' natural habitat. Conscious "Sachlichkeit" or "objectivity" certainly need not exclude selectivity. Parallel developments with similar subjects are known from American Straight Photography. Some of the plant pictures by Imogen Cunningham are reminiscent of Blossfeldt's austere photographs. Her *Echeveria*, a succulent with bell-shaped flowers, is depicted equally unsentimentally against a monochrome background. She is far removed from Edward Weston's photograph of a cabbage leaf, whose erotic intensity he has always denied, but the soft vein-structure comes across as no less sensual than an orchid flower. Nothing could have been more alien to Blossfeldt than this approach to the world of things.

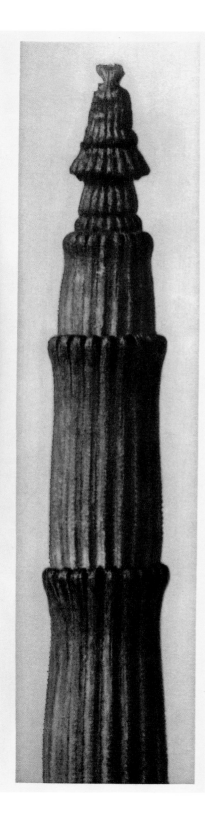
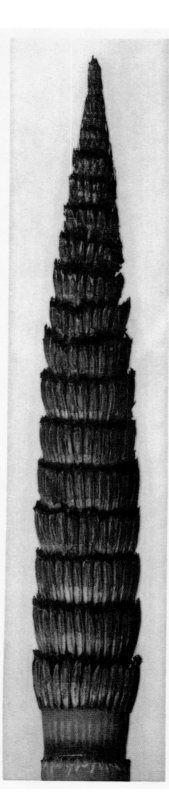
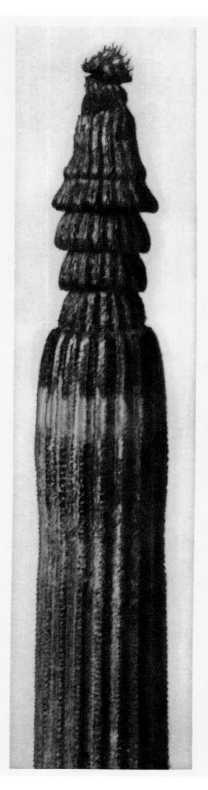

V. I. Lenin in the smolny

Oil on canvas, 198 x 320 cm
Moscow, State Historical Museum

b. 1884 in Sofiyevka (near Berdiansk), d. 1939 in Leningrad (today St Petersburg)

Isaac Israilevich Brodsky was one of the chief exponents of Socialist Realism, and for a time Director of the Academy of Arts of the USSR. In 1922 he was one of the founders of the Association of Artists of Revolutionary Russia. His pictures of revolutionary and reconstruction scenes after 1919, some of them based on photographs, form a kind of chronicle of the first decades of the Soviet Union. In 1920 he was commissioned to paint the inaugural session of the 2nd Congress of the Communist International. The resulting monumental picture was successfully exhibited at first, but a few years later disappeared from public view, because of its all-too realistic depiction of all the revolutionaries who had meanwhile been purged.

Brodsky by contrast adapted to the changed circumstances. His best-known Lenin picture represents the founder of the Soviet Union, who died in 1924, in his study, without any historic glorification; it is strongly reminiscent of the critical-realistic works of the 19th century. This picture exists as an original dating from 1930, as well as in the form of three identical versions by the artist, one dating from the same, and two from subsequent years. The copies toured as part of prestige exhibitions at home and abroad, while at the same time individual Soviet museums claimed them as part of their permanent collections. In its popularity, the picture seems to be obeying Lenin's dictum that "Art belongs to the people. It must have its deepest roots in the broad, creative masses. It must be understood and loved by them."

With his posthumous Lenin picture, Brodsky rises far above the fulfilment of the state's demands in respect of form and content: what we see is a tired-looking man in profile; his face is in shadow, he seems highly conscious of his responsibilities, and not to be taking his decisions lightly. The intention was for contemporary beholders to see that their representatives were acting responsibly and conscientiously. *V. I. Lenin in the Smolny* is far removed from the heroic Stalin pictures, almost all of the latter admittedly painted during the dictator's lifetime, often showing him in uniform, all of them idealized, and hardly ever doing specific work – at best as a jovial character consorting with "the people". He is the administrator of Lenin's estate, and the show is part of his legitimation. Lenin himself, by contrast, venerated in quasi-religious fashion after his death, is characterized by his actions – not just as a brilliant theoretician and eloquent orator of the revolution, but also as a human being with a ready ear for the cares and worries of all. For this reason he can be depicted in the petty-bourgeois atmosphere of his study in Smolny, then the seat of government, sitting in an arm-chair, making notes while reading a newspaper. Evidently Lenin's importance does not have to be staged; the operative function of the picture relies on the public's prior knowledge and existing admiration. This is why for us today the absence of pathos creates an impression of great self-assurance, even though the style of the painting can certainly be understood as a relapse into the naturalism of the 19th century.

V. I. Lenin, 1920

after the orgy

Oil on canvas, 140 x 180 cm
Private collection

**b. 1897 in Desenzano sul Garda,
d. 1946 in Venice**

Born as Natale Bentivoglio Scarpa, the artist chose the name Cagnaccio di San Pietro in about 1920. It was under this name, after brief excursions into salon painting and Futurism, that he became known as an exponent of the Italian variant of Neue Sachlichkeit, before he returned once more to a more traditional form of painting. He died in Venice, where he had spent the war years in hospital as a result of his critical state of health.

After the Orgy (Dopo l'orgia), dating from 1928, is an example of a suggestive Magic Realism à l'italienne. The striking thing about the three women in variously relaxed sleeping positions is their similarity: the pale skin colour, the chestnut hair, the smoothness of their muscular slim bodies all suggest that the same model sat for all three. In other words, that we have three views of one and the same exhausted person. The woman on the right-hand side has her arms folded behind her head and her legs somewhat stretched; moving clockwise, the next woman has pulled up one leg, while the third occupies the foetal position, her defensive attitude emphasized by the fact that she has her back to the beholder.

The surroundings, the stage-like construction with a half-open curtain in the upper third of the picture, come across as no less constructed. The relationship between the sharpness of reality and the exaggeratedly composed nature of the picture evinces a tension between the idea and the reality, which, since Franz Roh's analysis in the 1920s, has been seen as one of the characteristics of Magic Realism. On the red fitted carpet, which appears to be of a velvety consistency, there are indications that the scene was preceded by a dissipated party held by a bourgeoisie weakened by the Italian economic crisis of the 1920s, a bourgeoisie which helped to finance

Mussolini, who they hoped would uphold their interests. The detritus consists of two champagne glasses and bottles, and next to them, isolated like clues to whatever activity took place, a still-smoking cigarette which has burnt almost down to its filter, a bowler-hat lying on white gloves, playing-cards, and, as though just thrown away, the artist's signature on a piece of firm cream-coloured paper curled up top and bottom. Of the man or men, these are the only traces.

The impression created by this scene is more depressing than titillating. The exactness of detail and the unreal bright light in which the room is bathed convey a theatrically decadent mood, which, once the participants in the orgy have woken up, will probably be transformed into the disgust which comes with the cold light of day. Thus the three women depicted represent stages of ever greater withdrawal into oneself, flight from an external world to which, particularly with respect to the historical development, they are delivered up just as they are to the inexorable eye of the artist. With great precision, Cagnaccio dissects the vain attempt to escape reality: what remains is loneliness. This complexity fundamentally distinguishes Cagnaccio's painting from a hyper-realist sculpture by John de Andrea (b. 1941), where the motif itself is very similar: it shows a slim young woman for no other reason than that she is pretty and comes across as genuine. Her perfection can be enjoyed out of context, while the post-orgiastic women are inseparable from their temporal situation.

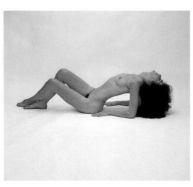

John de Andrea, Recumbent Figure, 1990

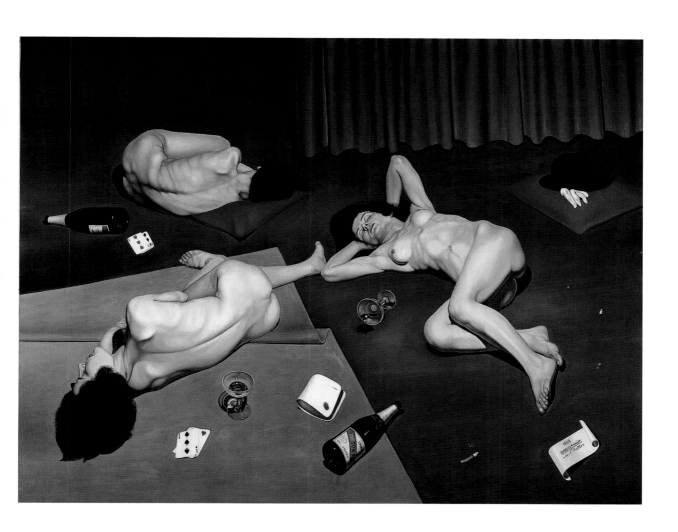

Big self-portrait

Acrylic on canvas, 274 x 212 cm
Minneapolis, Walker Art Center, Art Center Acquisition Fund

b. 1940 in Monroe (WA)

Chuck Close makes reproductions of reproductions. He began in the late 1960s to use photography to help him paint his large-scale portraits, mostly in acrylic. Objectivity is the goal of a painter who uses the raster technique to transfer greatly enlarged projections on to his monumental canvases and in this way to depict his friends and himself in exact detail.

The merciless precision of his technique can be seen in this large-scale *Big Self-portrait* dating from 1968. Greasy strands of hair are falling across his shadowed face; they also, in untidy fashion, frame his face, on which every hair of his stubbly beard can be distinguished, while on his bare chest a number of hairs can be seen, and the distortion makes his shiny nose look pointed. Close makes no secret of the fact that he is following the indirect reality of one or maybe more photographs, reproducing the specific flaws of the original. Thus particular parts of the face, the ears for example, are somewhat blurred, as in a photograph taken with a camera whose depth of focus does not extend to the whole picture.

Criticism of a fidelity to nature which merely captured the external likeness of a face without doing justice to the sensuous and intellectual individuality of the sitter was vehement, especially in the 19th century following the introduction of photography. It culminated in the topos of the "dead mirror", and its goal was to demarcate naturalistic or photographic reproduction of nature from the authentic art of a creative subject. Thus Friedrich Hebbel in 1859 issued a sarcastic polemic in which he attacked the "dull realism that takes the wart just as seriously as the nose on which it sits". But it is precisely the unprejudiced nature of this procedure that fascinates Close: "The camera is objective. When it records a face it can't make any hierarchical decisions about a nose being more important than a cheek. The camera is not aware of what it is looking at. It just gets it all down. I want to deal with the image it has recorded which is black and white, two-dimensional, and loaded with surface detail." His pictures are uninteresting if we regard them as mere reproductions of reality. As an analytical method, as a commentary on the photographic view, by contrast, interest in their artificiality and flatness is appropriate as a way of teaching how a picture should be read. This picture is not a consistently naturalistic reproduction of reality, although this criticism of Close's works – that they owed their existence to reactionary forms of depiction – has often been made; rather, with his colossal heads, Close is translating the photographic perception of reality into fierce presence.

Close uses different photographs for different parts of the picture, so that he can be said to use both analytic and synthetic techniques, the latter working with different focuses and bringing them together. The concentration on different focuses is the reason for his technique also being called Sharp-Focus Realism. He himself has described his technique as the attempt to filter his ideas through the camera – he is interested in artificiality rather than illusion.

> **"some people wonder whether what I do is inspired by a computer and whether or not that kind of imaging is a part of what makes this work contemporary. I absolutely hate technology, and I'm computer illiterate, and I never use any labor-saving devices although I'm not convinced that a computer is a labor-saving device."**
>
> **Chuck Close**

41

Female тextile workers

Oil on canvas, 171 x 195 cm
St Petersburg, Russian State Museum

**b. 1899 in Kursk,
d. 1969 in Moscow**

Aleksandr Deineka received during his lifetime many honours: not only the Lenin Prize, but the honorary titles of Meritorious Creative Artist of the RSFSR, People's Artist of the USSR, and Hero of Socialist Labour.

Female Textile Workers was painted in 1927, five years before the term "Socialist Realism" was coined at a meeting attended by Stalin, Maxim Gorki and the Soviet artistic and literary elite. The stylized depiction of women's work in this 1920s' picture is still far removed from the muscular ball-players and the idealized nakedness of his later rear-view nudes, which were designed for successful apparatchiks to feast their eyes on.

Three stylized, mechanical-looking young women, in whose faces, hands and legs warm ochre hues dominate, are depicted submerged in their work at the looms in cool blue surroundings. The woman in the centre, depicted frontally, is shown with her face lowered, clearly not even thinking about looking up from her work. Barefoot, their hair combed back in austere fashion, so that their facial features are clearly visible, and in light summer frocks beneath which the outlines of their slim bodies can be discerned, they are united by their work, their common goal. They seem to have adopted the rhythm of the circular movements of their looms. The machines behind them are no more than graphic elements, which emphasize the abstract quality of the picture. The fusion of the protagonists with their surroundings has been seen as reflecting the influence of Alexei Gastev's programme, developed at the "Central Institute of Labour" founded in 1920, for the Taylorization of life: a programme which regarded "new" industrialized man or woman as a machine. Behind the pane of glass, which lets clear light into the young women's workplace, can be seen in the top left-hand corner a patch of blue sky, while two calves are being driven past by a boy: the combination of industry and agriculture – in the picture, a convincing union, shows another utopia.

Deineka himself, in allusion to his pre 1932 industrial pictures, wrote: "I do not understand what a machine landscape is good for, when a malformed human being appears in it feeble and unfree." By the standards of his subsequent strapping sportswomen, the factory girls do indeed seem almost incorporeal, yet their concentration on their work is the expression of a presence which is missing from the naturalistic heroines of later works. The reductionism of the *Female Textile Workers*, something criticized as "schematism" as artistic attitudes became more dogmatic, is the expression of a mood of optimism which still comes across as fresh and not yet disillusioned; in its constructivist approach, it is far removed from the sultry idylls of Deineka's later years, which took up themes such as motherhood in conventionally classical fashion, expressing a purely operative view of artistic activity. The painterly quality, subtle coloration and atmospheric lightness are proof of the possibility of laconic and unheroic depiction of working life, and it is conceivable that the subjects of this Synthetic Realism represent better role models than most of the Heroines of Socialist Labour.

"Realism is not what real things are like, but what things are really like."

Bertolt Brecht

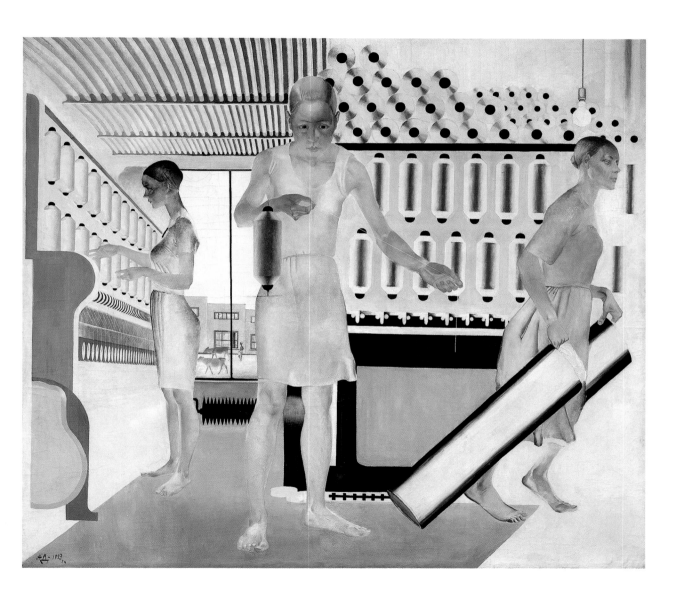

Portrait of the Artist's Parents II

Oil on canvas, 118 x 130.5 cm
Hanover, Niedersächsische Landesgalerie

"one must have seen people unleashed in order to know anything about them."

Otto Dix

b. 1891 in Untermhaus (near Gera),
d. 1969 in Singen

In 1924 Otto Dix was at the peak of his critical Verist phase. A year earlier, he had finished the picture *The Trench*, which was bought by the Wallraf-Richartz Museum in Cologne, but disappeared at the time of the Nazis' campaign against so-called "Degenerate Art" and has not been seen since. As far as its subject was concerned, it was regarded by contemporary critics as "perhaps the most gruesome picture ever painted". The folder of 50 etchings entitled *War* also appeared in the same year as *Portrait of the Artist's Parents II (Elternbild II)*: At this time, Dix was a reputable but controversial painter, whose merciless style encompassed all his subjects: prostitutes, the war-wounded, and his close relations. *Portrait of the Artist's Parents II* depicts the confinement and monotony of their working-class lives, in diametric opposition to the optimistic depictions of workers by, for example, the exponents of Socialist Realism. We see two tired people, their chafed hands in their laps, sitting huddled up tight on a sofa. While the father, in a striped collarless shirt, seems to respond to the gaze of the beholder with his reddened eyes, the mother, likewise simply dressed, is looking obliquely to the left: the eyes of the two do not meet, there is nothing to point to closeness or tenderness between them. The faces, the father's red nose, the mother's swollen veins, all come across as exaggerated, as in a caricature. The background is bare.

The precise encompassing of reality has often been seen in connexion with photography. In Paul Westheim's opinion, for example, Dix painted people "as though he were taking notes of an interrogation; he depicted them as though for police records, with great attention to detail and almost mechanical exactness". The caricature effect hinted at above is an indication that the artist wanted to exaggerate even the precision of the photograph, so great was his concentration on anatomical details, without regard for a uniform total impression. Dix himself judged the possibilities of capturing a subject in painting as "considered", in contrast to the superficial momentariness of the photograph; self-confidently, he noted: "100 photographs could only ever offer 100 different snapshots, but never the 'phenomenon as a whole'. Only painters see and create the whole." The *Portrait of the Artist's Parents* is the result of a lengthy work process; from 1920 onwards, Dix made numerous detailed studies of his parents' hands and faces, which served as the foundation for *Portrait of the Artist's Parents I* in 1921. *Portrait of the Artist's Parents II* was painted in Düsseldorf, a long time after visiting his parents in Gera (which is in a quite different part of Germany), so that his work could take in his observations and memories with no danger of any fixation on a particular moment. This process includes a reference to painting traditions and a carefully executed varnishing technique which Dix uses to obtain a strong colour effect. This colour effect was an important means of expression for him. "Now it's not only the form, but also the colour, which is of greatest importance, and a means of expressing individuality. All human beings have their own very specific colour, whose effect extends to the whole picture."

In contrast to the social typology of the Weimar Republic, which was developing at the same time, and captured by August Sander in his photographic portraits of *People of the 20th Century*, Dix focuses on capturing the individual aspects together with whatever social criticism this might imply.

Portrait of the Artist's Parents I, 1921

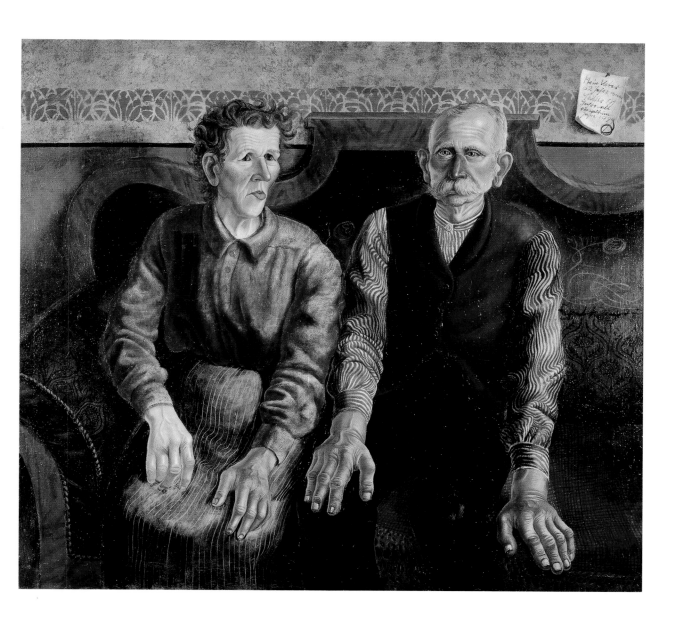

Double self-portrait

Oil on canvas, 60.8 x 91.5 cm
New York, The Museum of Modern Art, Mr. and Mrs. Stuart M. Speiser Fund, 594.1976

"I don't believe photography is the last word in realism."

Richard Estes

b. 1936 in Kewanee (IL)

Richard Estes describes himself as a realistic painter; alongside Audrey Flack and Chuck Close he is regarded as one of the leading early Photorealists. As a student at the Art Institute of Chicago he took an interest in traditional academicist painting, finding his theme in 1967, since when he has been the unrivalled master of the late-20th-century townscape.

The close adherence of his oil-paintings to his photographic originals – always ones he has taken himself – is evident in his *Double Self-portrait* dating from 1976. His arms akimbo, the artist stands beside his camera, which is attached to a tripod, and photographs precisely that section of a diner window which reflects the painting. Behind the window, we can discern a bar with stools upholstered in red, and a machine for dispensing cola. Also reflected in the glass are two cars, trees in bud, pointing to the season, and the shops on the opposite side of the street.

Apart from the twofold reflection of the photographer, there is no one to be seen in this picture, in which he demonstrates his self-assurance in respect of his photographic originals. Dispensing with any narrative element, Estes devotes himself entirely to the fascination of the various reflection effects, and to this end uses photography as an aide-memoire. Human beings would disturb the sought-after precision of Estes' depiction, and so his pictures are, with the exception just mentioned, mostly as empty of people as his 1978 *Downtown*.

Downtown depicts a crossroads with a variety of building styles, two cars, shop-windows and – as we said – no people. Everything in his hyperexact pictures is equally crisp, for "I don't like to have some things out of focus and others in focus because it makes very specific what you are supposed to look at, and I try to avoid saying that. I want you to look at all. Everything is in focus."

This all-over sharp-focus is the Photorealist equivalent of the all-over structure of abstract painting, a protest against the hierarchy implicity in any view dictated by the artist. This does not mean, however, that Estes makes no changes: "You make changes to make it closer to what it really is." In addition, he has no interest in simply enlarging a photograph, which is why he disapproves of the description "Photorealist". For his goal appears to be not the realistic reproduction of what is there, but rather an "ideal reality", which depicts comprehensible, ordered structures that have more to do with our reality than a mere clone of the visual image would do. Thus the pictorial effect is at first sight illusionist, entirely in the tradition of *trompe-l'œil* painting, tempting the beholder to assume the existence of a photographic source. But here too, just as in his views of classic motifs such as Venice or Paris, Estes has combined a number of photographic images to create a totality which, while in spite of its incorrect perspective, is nonetheless convincing. The result is literally almost "surreal", a kind of super-reality which distinguishes Estes' works from the abstractions of some of his fellow-artists.

Downtown, 1978

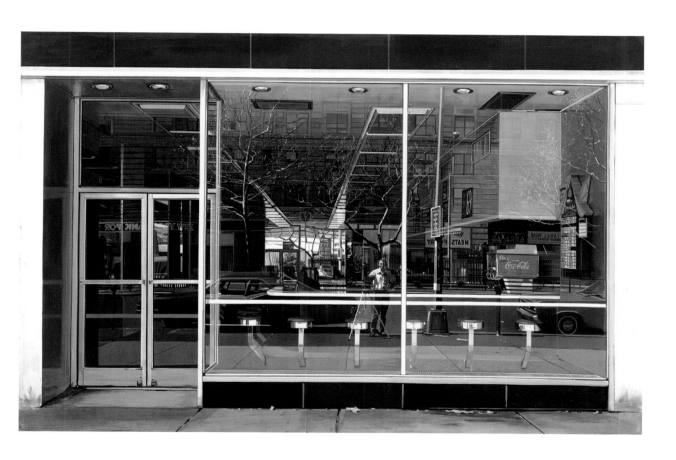

kitchen wall in вud ғields' нouse

Photograph, gelatine-silver print, 17.5 x 22.5 cm
Private collection

"ı am for man's work, nature bores me as an art form."

Walker Evans

b. 1903 in St. Louis (MO),
d. 1975 in New Haven (CT)

Walker Evans was the pioneer of the so-called documentary style, which, as its name implies, he employed to document in particular the everyday culture of the United States. He worked for fifty years to capture modern America in photographs. From 1935 to 1937 he worked as a photographer for the Resettlement Administration, later renamed the Farm Security Administration (FSA) and was commissioned jointly with the writer James Agee by the magazine *Fortune* to produce a report on small farmers (sharecroppers) in Alabama. The report appeared in book form in 1941 under the title "Let us now praise famous men" (a bible quote, Ecclesiasticus 44:1) with 31 photographs. The express aim of the work for the FSA was to collect source material.

The contribution of Walker Evans went far beyond mere documentation, but the manner of his aestheticization always respected what was depicted. The *Kitchen Wall in Bud Fields' House,* photographed in 1936, bears witness to Evans' sense of telling detail. We see a wall nailed together from rough timber, probably deal, the cheapest building material; to this wall, three narrow planks are fastened, serving as shelves for the family's modest cutlery, a plate and two mugs. The way they are fastened is simple, functional, and reduced to a minimum. As in other pictures of interiors, there is no superfluous decoration, the furnishing is bare and sober; all that can be seen are the traces of a poster on one of the planks, which may once have been part of the fence around a construction site.

The sharecroppers worked their tiny plot of land to pay for this home, their food, their clothing and their rent. Floyd Burroughs, whom Walker Evans portrayed several times, was one of these farmers. He is wearing dungarees, and a dirty, torn shirt; his nose looks sunburnt,

and his light-coloured eyes are half-closed. With great clarity, Evans has captured the exhausted and worried face of a hard-working man. Unlike much other allegedly socially committed documentation of human misery since, this picture includes the name of the subject, who can thus be assured of his identity like any celebrity sitter.

This and all the other pictures by Evans document his social conscience without his having recourse to the suggestive staging employed by Margaret Bourke-White, for example, whose melodramatic angles and lighting strategies he criticized, because in his view, they improperly exploited the subjects' situation. Evans' aesthetic work consists in encompassing what he sees and presenting it for what it is, an ability to see the present as though it were already history. This timelessness, which can emerge in dealing respectfully with what is seen, has been accurately described by the American novelist William Faulkner in an interview: "The aim of every artist is to arrest motion, which is life, by artificial means and hold it fixed so that 100 years later when a stranger looks at it, it moves again since it is life. Since man is mortal, the only immortality possible for him is to leave something behind him that is important, since it will always move." At the same time, with the label "documentary style", Walker Evans recognizes the subjectivity of his confrontation with what he finds.

Floyd Burroughs,
Cotton Sharecropper, 1936

The Bed, The chair, Dancing, watching

Oil on canvas, 175 x 198 cm
Private collection

b. 1948 in New York

After an abstract early phase, Eric Fischl has been painting figuratively since 1976. He spent his childhood in the suburbs of Long Island, with their contrast between a smooth surface and the underlying dramas. It is just this contrast that feeds the spectrum of pictures of an artist whose depiction of a masturbating boy and a thief in a naked woman's room was the stuff of early scandals.

Fischl's observations of the American middle class have often been attacked as voyeuristic. The picture *The Bed, The Chair, Dancing, Watching*, painted in 2000 as one part of the 15-part series *The Bed, The Chair ...* dating from 1999 to 2001, comes across as a commentary on this criticism. In the centre stands the observed observer, a man on a cocktail chair decorated in red bamboo, the object of his desire is visible as no more than a shadow on the bedroom wall: a woman moving lasciviously with her hands raised above her head, and she is dancing on the very spot where the beholder of the picture is standing. Thus we can concentrate on the gaze of the man, which alternates between concentration on his part and resignation, and we can read the picture as a commentary on the male perspective.

As the man's gaze is directed towards an external point, namely the beholder, and at the same time towards something which this beholder can only see as a shadow at the rear of the picture, our imagination is occupied with forming a picture of the lust-object of the man, which only he can see. Our gaze circles about the room, where the bed in the background, the only other object, becomes a possible indication of the action hinted at by the gestures of the protagonists. This game with levels of representation has its precursors in the history of painting, the most famous being *Las Meninas* by Velázquez

(1599–1660), where the beholder likewise stands in the place of the actual subject of the depiction, setting in motion a complex interplay of gazes.

Fischl's way of handling models and the sparing use of props has the effect of a concise capturing of actual configurations. His technique, however, consists in working with a core repertoire of pictorial elements, which are reassembled anew every time in order thus to generate expressive scenarios, which cause the beholder to oscillate between unease and fascination. The photographs he has taken beforehand do not serve as aids to memory, but are combined to create associations. The protagonists' body language produces a feeling of recognition which holds us in its spell because it awakens the power of memory in the way that a once-familiar smell can do. Fischl's obsession with human figures and sexuality is the expression of a subjectivity to which he admits, and which is in continual dialogue with his world and his surroundings. Thus a logically consistent work is created, whose source Fischl has commented on in the following terms: "My ideas of painting have remained if anything constant to the extent that I have always thought that painting should follow life and point to where life is leading." Fischl's pictures want to tell a story, and even when the choice of subject only embraces a small part of the reality of life, they are familiar and comprehensible.

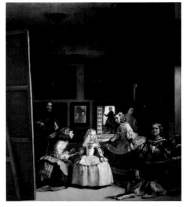

Diego Velázquez, Las Meninas, 1656

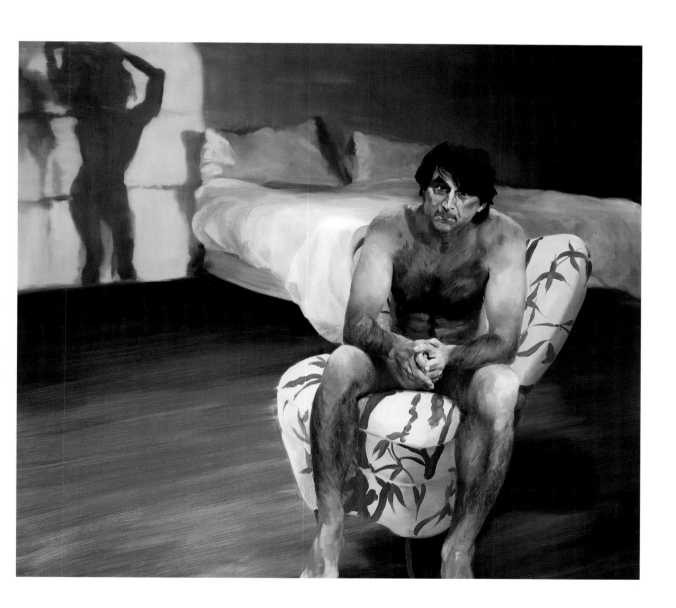

Nude with Leg up (Leigh Bowery)

Oil on canvas, 183 x 228.5 cm
*Washington D. C., Hirshhorn Museum and Sculpture Garden,
Smithsonian Institution, Joseph H. Hirshhorn Purchase Fund, 1993*

"I would wish my portraits to be of the people, not like them. Not having the look of the sitter, being them."

Lucian Freud

b. 1922 in Berlin

Lucian, Sigmund Freud's grandson, was born in Berlin, and in 1933 emigrated with his family to England, where he became perhaps the most important portrait painter of the 20th century. The art-critic and author Robert Hughes even called him the "greatest living realist painter".

His eccentric extension of the portrait genre to include naked portraits, which have nothing in common with conventional nudes, has made him something of an exceptional character among figurative painters. *Nude with Leg up (Leigh Bowery)*, painted in 1992, is typical of Freud's approach to a real person, an approach which has nothing to do with creating a meticulous likeness, but with artistic transformation. The sitter, Leigh Bowery, a legendary performance and disguise artist, fashion designer and bandleader, who died of AIDS in 1994 at the age of just 33, often acted as Freud's model from 1990 on, and the artist valued him highly. As someone with experience as a dancer, and used to public performance, the sitter exudes the easy confidence which Freud sees as the basis for capturing the essence of his subjects, for he never dictates poses, but allows himself to be guided by the models who stimulate him to artistic confrontation.

Bowery is lying on a wooden floor in the middle of the studio, his right leg is resting, bent at an acute angle and yet relaxed, on a green-and-beige striped mattress on a metal bedstead, while his upper torso is supported by a mountain of cloth, a prop which is used time and again in Freud's scenarios. The body comes across as calm and heavy, while the eyes, directed towards the painter, express the greatest possible matter-of-factness. The drastic depiction of the exposed genitalia is reminiscent of Gustave Courbet's (1819–1877) famous 1866 painting *L'Origine du monde*, which shows the female

pubic region in frank close-up. Freud, though, is not concerned with erotic charisma, but with natural, sexually charged physicality, whose unpretentious shamelessness can lead to acceptance.

The treatment of the flesh tones evinces an abundance of different shades and all in all produces a relatively coarsely structured surface full of nuances. For the depiction of the skin, Freud mixes the colours with a high proportion of Kremser Weiss (a kind of white lead), in order to give the applied paint a palpably material, pasty and grainy character. The emphasis on paint as material, plus the time-consuming painting process without any preliminary studies, results in a monument which does justice to Freud's claim to have the paint come across as flesh. In this picture he succeeds in depicting without a mask someone who loved disguises: a strong personality, whose authenticity is palpable.

The aim of this and other naked portraits is to generate "presence", something which in the age of photography can no longer be taken for granted: "In a culture of photography we have lost the tension that the sitter's power of censorship sets up in the painted portrait." The difference between photography and painting lies in "the degree to which feelings can enter into the transaction from both sides. Photography can do this to a tiny extent, painting to an unlimited degree." The condition is the skill and intensity of a painting technique which uses photographic aids to memory only in addition to time-consuming studies of real people.

Gustave Courbet, L'origine du monde, 1866

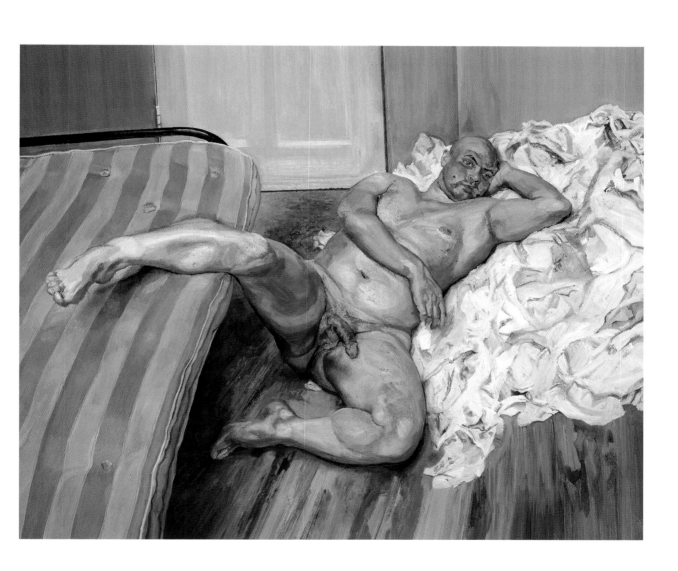

Riot I

Acrylic on canvas, 305 x 416.5 cm
Courtesy Ronald Feldman Fine Arts, New York

==

**b. 1922 in Chicago,
d. 2004 in New York**

For half a century, Leon Golub, who was born in Chicago in 1922, has been painting in protest at various forms of violence: from the *Napalm* pictures via the *Vietnam* cycle to the *Interrogation* series and *Riots* of the 1980s. On huge canvases – *Riot II* measures 305 x 416.5 cm – he creates an impressive fusion of form and content. The raw violence of the four protagonists, who continue to torture the faceless victim even after his death and humiliate him still further by urinating over his head, is reflected in what Golub does to the canvas: the acrylic paints, having been applied, are scraped off again and what remains is a cracked, furrowed surface of toned-down colour. The canvas itself does not escape unscathed either: about one-eighth at the bottom left is torn off, so that one can only see half of the supine victim and is forced to supply the rest in one's mind's eye, to presume that the man armed with a stick in the middle of the picture is kicking the man on the ground. The effect is further heightened by the fact that the man standing at the far left, with the casually knotted shirt and cigarette hanging from the corner of his mouth, is looking towards the beholder, a look to which the latter has to react just as he does to the self-assured grins and the obvious pleasure the perpetrators are taking in their sadistic act.

No specific setting is named, the undifferentiated burgundy provides no clues to the scene of the crime. Golub seems not to be concerned to illustrate a precise event. The painting is, however, based on a photograph dating from 1976, which depicts the murder of left-wing students in Thailand. The originally 13 to 16-year-old boys come across in Golub's painting as older, and here they are Westerners, in some cases in garishly coloured clothes, for example a canary-yellow shirt. But what is of interest here is not the specific situation, of a sort which newspaper readers have now become inured to through countless such documentary photographs. Golub reminds us of violence as a human constant and forces the beholder to think about it in a context which for many is a zone of contemplative pleasure, an "art-for-art's-sake" mindset. This is why we must read the pictures as a description of existing facts, even though they have lost their purely documentary character through the artistic transformation. Thus Golub also says of himself: "I think of myself as a reporter. I report on the nature of certain events. I think of art as a report of civilization at a certain time."

His supporters see Golub, who saw Picasso's anti-war picture *Guernica* at the Arts Club of Chicago in 1937, as the conscience of figurative painting; his critics call his approach agitprop. But for him art would be inconceivable if it did not refer to or confront the real present. His painting is comprehensible to all, and it proves more intensely than any portrayal of violence now consumed by the public via the media that there is no reconciliation in sight. Leon Golub's view has not been softened by age.

Riot II, 1984

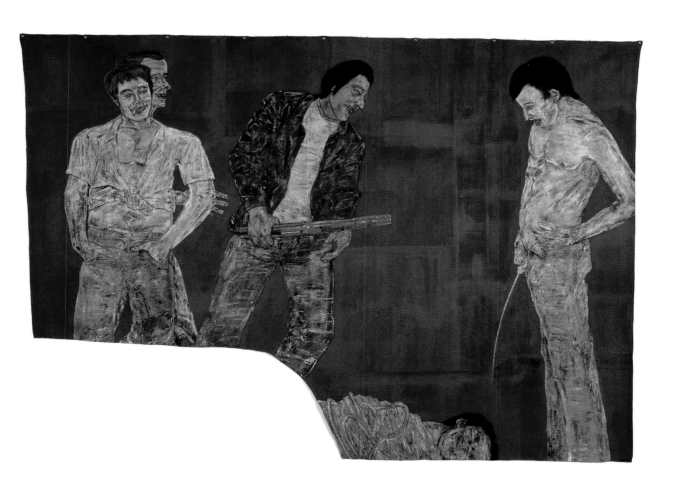

woman with shoulder-bag

Polyester, synthetic resin, tallow, reinforced with fiberglass, oil paint, items of clothing, wig, height 163 cm
Cologne, Museum Ludwig

"People like to people-watch, but they feel guilty about it."

Duane Hanson

b. 1925 in Alexandria (MN),
d. 1996 in Boca Raton (FL)

With his sculptures of middle and lower-class Americans, Duane Hanson has become the best-known realistic sculptor of the 20th century. He got to know the material polyester resin while staying in Germany with the sculptor George Grygo. By the use of a casting technique, this material allows the detailed copies which the artist needed for his depiction of the reality of life in everyday America. Hanson's figures come across as so real because the poses they adopt – frozen moments of contemplation – are just as familiar to us as are the perfectly chosen props, accessories like the artificial-leather handbag hanging over the shoulder of the lifesize *Woman with Shoulder-bag* dating from 1974, as well as her clothes, like the polyester sports shirt and the trousers stretched over her bulging hips.

Important for the effect of this woman, who has been captured in a state of obvious exhaustion, her hand weighing heavily on her bag, is the fact that museum visitors confront her at eye-level (she is standing on the floor) and thus share, quite literally, her level of reality. The careful painting of the skin, the tiredness that speaks out from every wrinkle on her face, strengthen the element of confusion, but unlike the hyper-realistic nudes of John de Andrea, which look as if they have been created for a waxworks show, this confusion serves to generate a sense of recognition and shock: the physical presence of the figure does not, on closer inspection, give way to disappointment that it is not a living person, but rather to a sense that one is faced with an individual whom the beholder looks on with sympathy.

In earlier works, Hanson devoted himself even more emphatically to real distress, for example in the 1967 piece *Riot*, a perceptive observation of race riots in the United States, or *Bowery*, dating from 1972, a scenario which derived from the misery of the homeless in New York. But even if Hanson has evolved from expressively staged groups and situations to increasingly static, more precise individual figures, his sympathy with his subject is still palpable. This applies also to the *Woman with Shoulder-bag*, who is depicted as suffering from reality: she could be just another museum visitor, but with her gaze directed into empty space, her wan complexion, narrow mouth, and unkempt, badly cut hair, she seems to have little in common with her numerous cultured fellow-visitors.

Like all the other sculptures, this woman has been transferred to a museum environment in which she is obviously not at home. This kind of de-contextualization, which forces us to take a new look at the seemingly familiar, is also one of the features of Oliver Sieber's (b. 1966) photographic series *Album*. In this series he photographs people – often they are snapshots capturing particular poses – from his own personal environment, isolates them, and transfers them to separately photographed museum galleries. Against this neutral background *Kathi*, for example, suddenly comes across like a Hanson sculpture, because she is frozen for ever in her movement. The effect emanating from the combination of precise and realistic "capturing" on the one hand, and removal from a familiar context on the other, helps us to understand sociological associations and forces us to concentrate on what is left when a person is isolated and yielded up to observation. At the same time, the photographs show us how perception is reduced by the change from three dimensions to two.

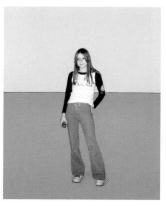

Oliver Sieber, Kathi, 2003

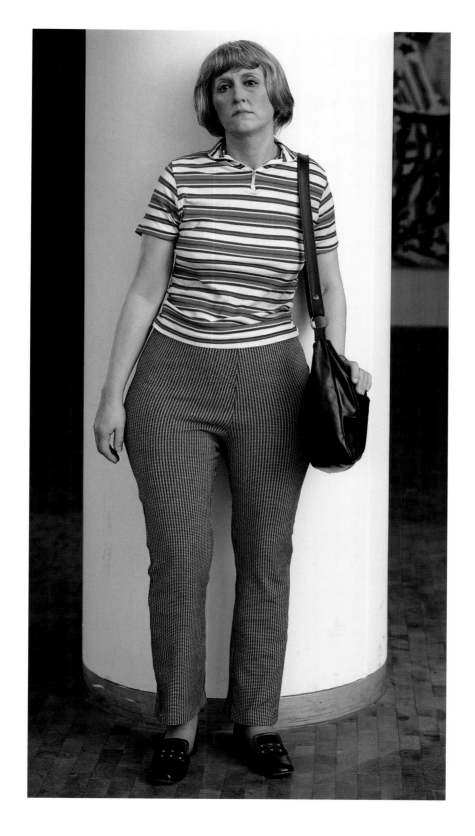

morning sun

Oil on canvas, 71.4 x 101.9 cm
Columbus, Columbus Museum of Art, Museum Purchase, Howald Fund 1954.031

> **"Nothing really influenced me. I don't think anything of the sort. Every artist has a core of total originality. An identity all his own."**
>
> **Edward Hopper**

**b. 1882 in Nyack (NY),
d. 1967 in New York**

By the 1930s, Edward Hopper was already regarded as one of the "giants of American painting". His consistent and caesura-free œuvre was created in New York, where he lived, apart from two brief sojourns in Europe, from 1908 until his death.

The painting *Morning Sun*, dating from 1952, shows a woman sitting on a bed with her knees drawn up, exposed in the cool morning light, her head turned to the open window. She is wearing a short salmon-pink shirt, its colour matched by her make-up. The room itself is bare. As there are no personal details such as a picture on the wall, only the tidy white bed, it could be a hotel room. Two constants in Hopper's pictorial output are visible in this picture. One is the relationship between interior and exterior – separate, yet linked by the motif of the window, through which, however, the woman's gaze does not penetrate to the outside, as she seems to be imprisoned within herself. The other focus is the importance of the light and its effects, which turn up time and again in Hopper's pictures: "Perhaps I am not very human. My concern was to paint sunlight on the wall of a house." In a preliminary study for this painting, it is possible to see that his interest focused on the way the light fell on the woman's body. In the painting, a sunny rectangle can be seen on one wall of the room, but although the room is bathed in light, it seems cold, and the pale skin of the woman, whose face comes across as an expressionless mask, shows reddening on her hands and toes, and a slight shiver seems to jump across from her to the beholder. The only warm effect is generated by the powerful ochre hue of the brick building outside the window, with the water-tower in the background. The woman herself, by contrast, seems to be trapped in the coldness of the light, which turns her into a monument of isolation.

This use of colour to create sensuous effects is equally apparent in the work of the American photographer William Eggleston (b. 1939), the legendary pioneer of the new aesthetic of colour photography. *Untitled (Huntsville, Alabama)*, dating from 1969/70, shows a similarly expressionless person, a man sitting on a motel bed with a glass in his hands. Here it is fluorescent lighting which embraces the empty walls and the man, who is captured in profile: the scene seems to express the loneliness of all hotel rooms.

This persistent penetration of the visible with the aim of showing the invisible – namely, comprehensible human moods – is what makes Hopper's Realism a Realism of the subconscious, which is revealed in the reading of the picture. The American art-critic Clement Greenberg once said of Hopper: "Hopper is simply a bad painter. But if he were a better painter, he would probably not be such a great artist." The patience with which he works on the visible leads to a quality which has nothing to do with virtuosity, but a great deal to do with insight: once one has looked at the lonely woman in the morning sun for long enough, there is no escaping the feeling of abandonment that shrouds her in her painfully empty room like a second skin.

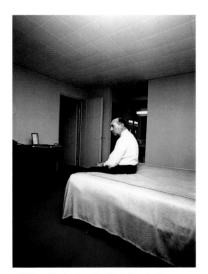

William Eggleston, Untitled (Huntsville, Alabama), 1969/70

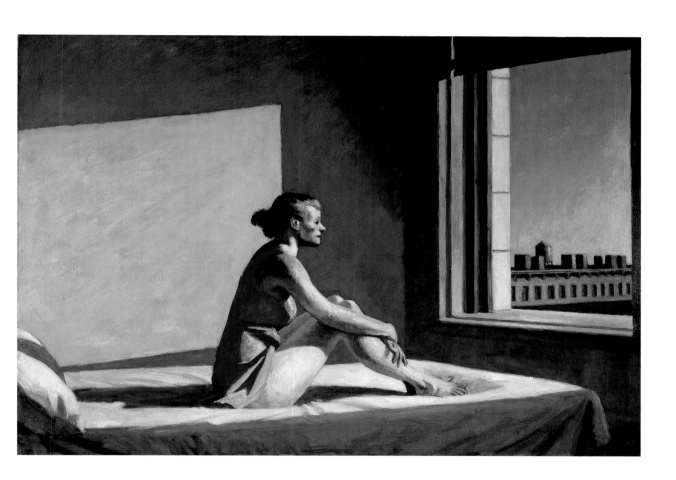

self-portrait with cropped нair

Oil on canvas, 40 x 28 cm
New York, The Museum of Modern Art, Gift of Edgar Kaufmann, Jr. 00003.43

**b. 1907 in Coyoacan (Mexico City),
d. 1954 in Coyoacan**

The daughter of a German father and a Mexican mother, Frida Kahlo has always protested at being adopted as a Surrealist by the Europeans: the myths she painted time and again in her pictures, including her numerous self-portraits, were her reality. And it is difficult to imagine a more dramatic reality than hers. In 1925 she was seriously injured in an accident. She died as a convinced communist in 1954: the last painting on her easel was an unfinished portrait of Stalin.

In almost every self-portrait, Kahlo is depicted in Mexican clothes and pre-Columbian jewellery, thereby demonstrating on the one hand her credentials as a member of Mexico's indigenous community, and on the other stylizing her femininity in eccentric fashion. Her husband, the painter Diego Rivera, valued not only these costumes but also her long black hair. On the 1940 *Self-portrait with Cropped Hair* Kahlo dispenses with these attributes of femininity. She is depicted sitting upright on a yellow chair on an orange-red floor, wearing loose masculine attire. The floor is covered with her black hair, which has just been cut off, and seems to be leading a life of its own, writhing around her feet and the legs of the chair. Kahlo here rejects the traditional feminine image by laying aside the insignia of her beauty and sensuality.

A line from a Mexican popular song at the top of the picture explains why she has taken this step: "Look, when I loved you, it was because of your hair; now that you are shorn, I don't love you any more." But what remains, while it seems to be marked by the pain of the recent separation from her husband, is at the same time the expression of great self-assurance. Kahlo looks at the beholder exploringly from big eyes beneath dark eyebrows which grow together in the middle, a woman who translates strong physical and emotional torments into pictures of great exactitude and yet tells not just of pain but also of its conquest through art. However, she attaches no importance to preserving proportion and perspective; she is interested in details, such as here the seemingly live hairs on the floor, which, together with her concentration on the themes of pain and desire and death, allow a singular form of self-presentation.

In contrast to many of her other self-portraits and allegories, which are populated by animals and full of luxuriating Mexican flora, we see here a woman in desolate surroundings, drawing all her support seemingly from herself alone. Kahlo's strength of will has often been talked of, and it is indeed striking how her torments brought forth an art of survival which radiates precisely this strength. Dramatic as Frida Kahlo's life-story was, what remains are pictures that bear its stamp, albeit with "relaxed cruelty", as Diego Rivera once called it, taking up valid feminine themes, including sex as for example in the unusual depiction of the female sexual organs. These are self-depictions without any narcissism, giving insights into her physical and emotional state, but which, in spite of their highly individual syntax, are not hermetic, and parade before the eyes of every beholder his or her own mortality.

> **"I was considered a surrealist. That is not correct. I have never painted dreams. What I depicted was my reality."**
>
> **Frida Kahlo**

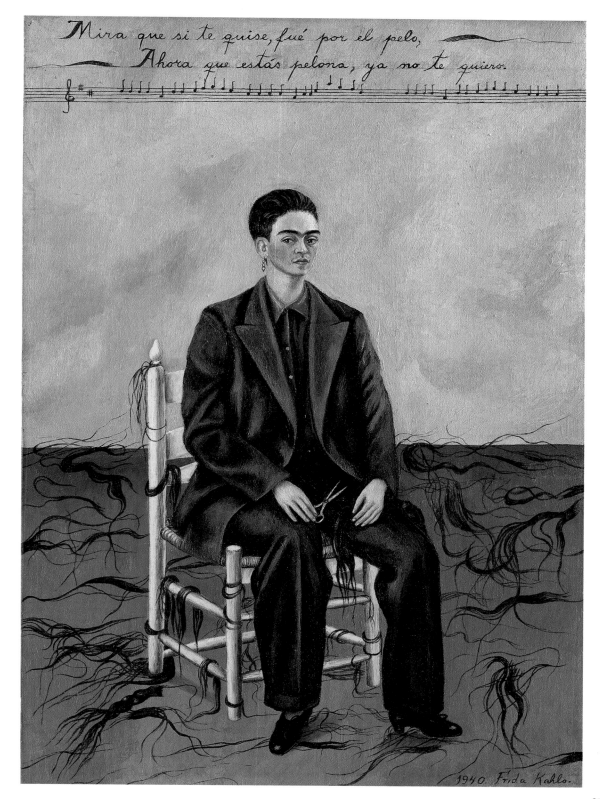

Portrait of the Duchesse de la salle

Oil on canvas, 161 x 96 cm
Private collection

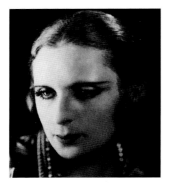

**b. 1898 in Warsaw,
d. 1980 in Cuernavaca (Mexico)**

Tamara de Lempicka was born of a patrician Polish family, went to live for a few years in St Petersburg, and after the Russian Revolution left for Paris, where she studied under Maurice Denis and André Lhote, from whom she at first adopted a "bourgeois" Cubism which she successfully combined with stylized, plastic figures. In 1938 she went to live in America, later on moving to Mexico where she died after having made relatively unsuccessful excursions into melodramatic social criticism and abstraction. The 1920s and 1930s were the heyday of this "painter of the world".

During this period she celebrated her greatest artistic successes, painting a large number of portraits in her unmistakably cool, almost metallic style. Cubist reminiscences appear only in the background, as in the *Portrait of the Duchesse de la Salle*, which dates from 1925. The dominant feature is the almost lifesize depiction of the duchess in riding gear. She is standing casually with her legs apart on a staircase with a red carpet. The city is visible below, so that she can be seen as dominating that, too. Her face is made up, the crimson lipstick harmonizes with the carpet, her cheeks are rouged, and a small beauty spot can be discerned on her upper lip. Her right arm is bent, with the hand in the trouser-pocket, while she is leaning with her left arm on what may be a banister, but which is covered with a drape.

This robust posture can be seen as altogether paradigmatic of a space-dominating "masculine" body-language to which conventional role-assignment is not applicable. Iconographically, Lempicka is moving in the tradition of masculine ruler portraits. The hips and thighs of the sitter are emphasized by the riding coat, whose tails are flung wide open and seem to frame them like a tent, while the left hand is pointing to her crutch, drawing attention thither, as do the trouser legs with their inconsistent cut: the right leg is skirt-like in its bagginess, while the left is skin-tight over the thigh.

The woman's sexual organs, though covered, are in the dead centre of the picture, apparently an indication of the woman's self-determined sexuality. Self-assured, her deep-violet hair cropped close to her head in the page-boy style with a dead straight parting down the middle, she embodies the archetypal androgynous woman, an image adopted years later by Marlene Dietrich. Looking at photographic portraits of the artist, we realize that like Dietrich, she knew how to mystify her own person and to cultivate the image of a sophisticated, self-assured, active woman of the world.

Just as she wanted to see her own life handed down to posterity as a piece of fantastical self-design, Lempicka always asserted the real existence of the sitter, but it is much more likely to be a fictitious creation, for none of the relevant genealogical reference works contain any mention of a duchess of this name. That could be interpreted as a sign that Lempicka identified with this imaginary sitter, seeing in her the realization of a self-sufficient woman whose aggressive approach to sexuality could be seen as the leitmotif of her own lifestyle, which was characterized for a while by countless liaisons, making her an icon of Art Deco.

"My objective: never copy. create a new style, bright, radiant colours, and pinpoint the elegance in your models."

Tamara de Lempicka

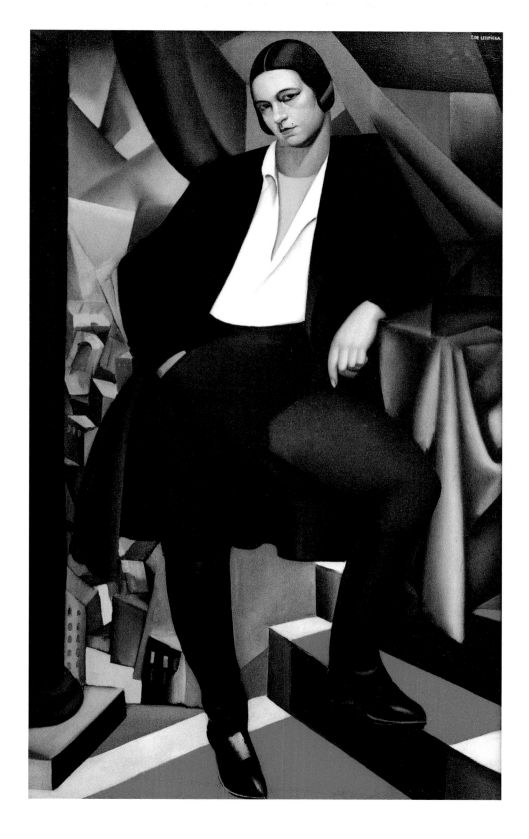

⊤he commendation

Oil on hardboard, 124.5 x 100 cm
Berlin, Alte Nationalgalerie

**b. 1927 in Reichenbach,
d. 2004 in Leipzig**

Wolfgang Mattheuer is one of the chief exponents, alongside Bernhard Heisig and Werner Tübke, of the so-called Leipzig School. After studying at the Hochschule für Grafik und Buchkunst in Leipzig, he became a teacher there, and from 1965 to 1974 was a professor at the institution.

Mattheuer acknowledged his commitment to socialism. In many of his pictures there is a clear attempt to strike a balance between the maxim of true-to-life depiction on the one hand, and criticism of the communist regime in East Germany on the other. *The Commendation (Die Ausgezeichnete)*, dating from 1973/74, is a portrait of a tired-looking woman with closed eyes, sitting at a table on which a somewhat lost-looking bunch of tulips is lying on a white tablecloth. Her feet are placed parallel, and her arms are hanging down – both gestures apparently expressing a certain resignation.

Most contemporary critics in East Germany saw the woman as the embodiment of an ordinary person embarrassed by the commendation she has just received, but there were voices which saw the picture as raising the question of whether the individual in the system could be lonely or feel misunderstood in spite of official recognition. In fact it is not too difficult to see *The Commendation* as a relatively open criticism of prevailing conditions. The sitter – Mattheuer's mother – has little in common with a heroine of the working class, and the picture is neither meant for show, nor is it so boundlessly positive as Party Secretary Walter Ulbricht, for example, demanded in 1953 on behalf of a vigorous and energetic "people".

Formally, Mattheuer's work is reminiscent of Neue Sachlichkeit. The wrinkles in the woman's face are captured with precision and sharpness, and her pose seems to be an expression of her mood: she comes across as isolated, and cannot return the beholder's gaze. It would be hard to think of another more convincing picture of the ambivalence of representational function and personal withdrawal. Mattheuer himself certainly intended this dual meaning: "I have never asserted of my *Commendation*: 'This is absolutely how it is.' Rather it is a fragment of truth, a special fragment perhaps – namely that little fragment that is too easily forgotten, because it is not a cosy fragment of truth."

It was doubtless this palpable scepticism which the photographer Evelyn Richter (b. 1930), whose works often criticized existing conditions in East Germany, found so stimulating in Mattheuer's picture. For example in her 1960 series about working women in East Germany, one sees on the one hand their self-confidence, while at the same time there is unmistakable criticism of their working conditions. In Richter's 1975 photograph *The Commendation,* one of the two exhibition visitors stands with her back to Mattheuer's painting and seems to be looking out of the picture, as though she had recognized in it a truth which she found oppressive. Clearly palpable in Mattheuer's painting is what he formulated in 1994 as the maxim of artistic production: "Art does not have a transforming effect, we must rid ourselves of that belief. Art can make us conscious of something. We live in an age when it is important to ask questions."

**Evelyn Richter, The Commendation,
1975/1988**

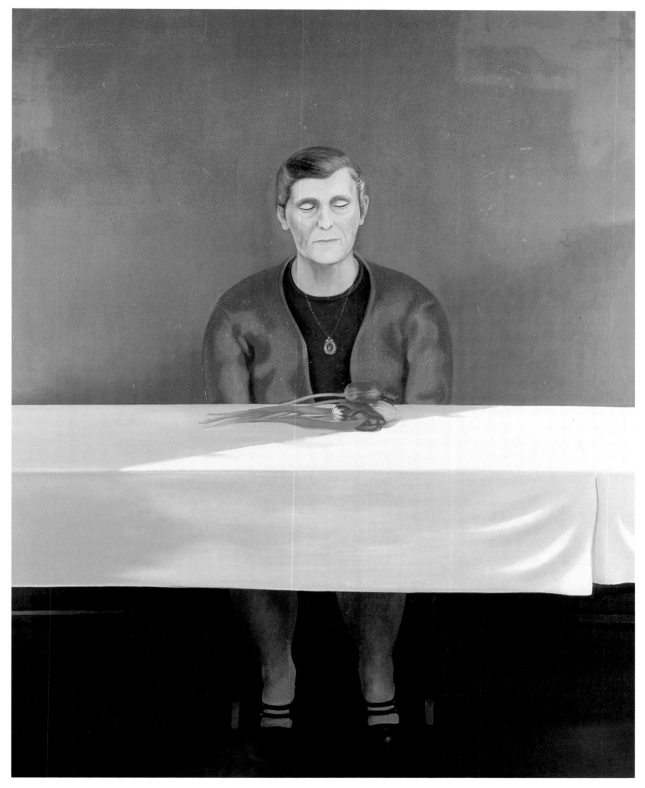

still-life

Oil on canvas, 37.5 x 45.5 cm
London, Tate Modern

**b. 1890 in Bologna,
d. 1964 in Bologna**

Giorgio Morandi painted very few subjects during his career, but in spite of this, his abilities were recognized at an early stage. In 1930 he became professor of etching technique at the Accademia di Belle Arti in Bologna, where he taught until 1956.

By the time of his 50th birthday in 1940, he had painted less than one-fifth of his total œuvre; the remaining major part of his works dates from the last third of his life. The range of motifs in Morandi's still-lifes is extremely narrow. The *Still-life (Natura morta)* illustrated here, with five ceramic vessels, dating from 1946 is a typical composition from the inventory of bottles, vases, dishes and bowls which he kept in his studio for this purpose. The need to have his motifs in front of him for as long as possible led him at a very early stage to dispense with organic and thus perishable objects. The colour impression of the picture is that of a greyish-white paleness shot through with coloured highlights. These latter are bound up with the shapes: the bowl on the right is pinkish, the vessel in the middle foreground is decorated with brownish-purple stripes, and the top half of the one on the left is lemon-yellow. All the corners in the picture are rounded off with soft, slightly wavy brush-strokes, the straight lines are shallow arcs which seem to obey the logic of the pictorial surface rather than delineate the objects and blocks of colour. For Morandi, who was continually quoting him, the greatest of all still-life painters was Jean Baptiste Siméon Chardin (1699–1779), who was no master of a smooth, dry painting technique either, but built up his pictures with daubs of thick paint. Both tried to forget how other painters before them had painted similar objects. The starting point for Morandi's painting, in which all the proportions are rhythmically attuned, was not the mimetic character of the available and familiar motifs, but their appropriation in almost meditative fashion.

Morandi was aware of the risk of monotony and repetition in view of his restriction of his range of motifs to just a few: "My subjects have always been restricted to a narrower field than those of most other painters, so that I have run a greater risk of repeating myself. I have, it seems to me, avoided this danger by giving more time and thought to conceiving my pictures as variations of the one or the other subject." His pure balances of colour and form with a wilfully limited palette force the beholder to pay attention to nuances, to tiny shifts.

In an essay, John Berger has described his impression of the pictures from the period from which this one dates; it is as though the objects were approaching the canvas, and arriving while Morandi waited. He calls him the most surreptitious artist there ever was. That his pictures do not come across as repellent or inaccessible is due to the quality of expression, which, together with the multiplicity of variations, trains a comparing eye and plunges the beholder into a universe full of beauty and melancholy.

His fellow-artist Giorgio de Chirico recognized the contemplative nature of Morandi's pictures as early as 1922: "His eye is that of a man who believes; he preserves for the innermost nature, the structure of these dead things, for in their motionlessness, they appear in his view more comforting: in his eternal view."

**Jean Baptiste Siméon Chardin, Still-life with
pomegranates and grapes, 1763**

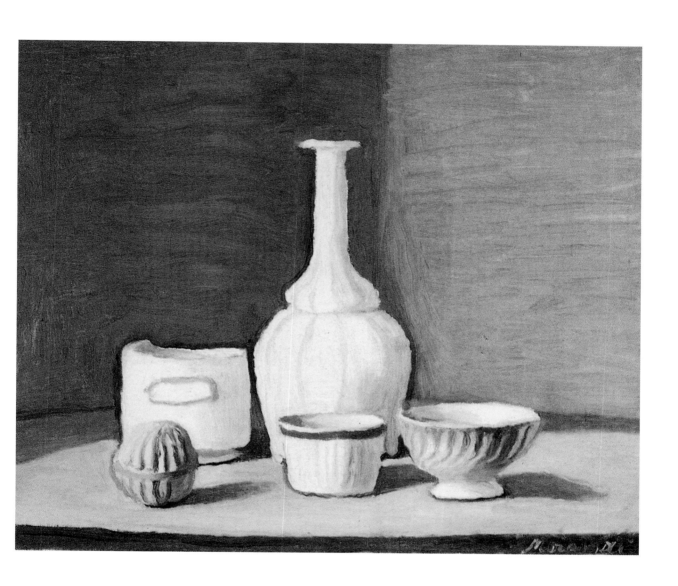

Dead Dad

Mixed Media, 20 x 38 x 102 cm
London, The Saatchi Gallery

b. 1958 in Melbourne

The career of Ron Mueck looks almost too good to be true. As the son of German immigrants, and trained as a toy-maker, he worked for years as a model-maker for films and television before deciding in 1996 to work as a freelance sculptor, and, with, of all things, his version of *Pinocchio*, the archetype of a not only true-to-life, but living, puppet, he was discovered by the international art scene.

The realism that speaks through every pore, every hair, every discoloration in *Dead Dad*, dating from 1996/97, is striking. But for all its precision, the depiction does not call to mind a waxworks show, quite apart from the fact that the sight of this person is nothing for the merely curious; there is nothing sensational about his death, the would-be beholder will approach with great caution. The merciless nature of the depiction, from the horny soles of the feet to the cracked finger nails, is reminiscent of the shocking frankness of the Late Gothic period, in particular Hans Holbein's *Body of Christ in the Tomb* of 1521, which makes such a real impression. In other respects, the fact that this is not lifesize, but so to speak a scale model 102 centimetres long (other sculptures are larger than life) forestalls any notion that this might be a real corpse.

The eyes of *Dead Dad* are closed, the mouth is reduced to a thin line, the greying hair is combed back, the hair on the legs is real – in this case, the artist's own, no less, which imparts to the sculpture some of the character of a relic. The body lies there stiff, and our impertinence in looking at it makes us aware of how unfamiliar this sight is. Death is a social taboo, and this small figure rightly makes us aware of what we suppress. The effect is so immediate that one might think that *Dead Dad* looks dead because he is dead, not because it is an inanimate sculpture. It could serve as a *memento mori* – and in addition, it conveys, as nothing comparable could, the impression of loneliness.

In addition to creating a stunning effect, Mueck succeeds in creating sculptures that stay in the memory. They are the concentrated expression of particular conditions of life and particular emotional states, and their introversion lifts up our own gaze before our eyes.

The manufacture of the figures from fibreglass-resin and various other materials is time-consuming. One particular reason is that while Mueck works on the sculptures in co-operation with live models, the sculptures sometimes exist for months in clay while the artist works on the correct proportions, a process that no longer has anything to do with copying the model. Even now, our visual memory is populated by the end results: those who saw his *Boy* squatting at the 2001 Venice Biennale will not forget it any more than they will forget the artist's dead father. The fact that this work was first exhibited in the exhibition entitled "Sensation – Young British Artists from the Saatchi Collection" is evidence of its popular entertainment value. But that does not reflect the heart of its effect, nor Mueck's intention: "I wanted to do something which a photograph could not do justice to. Although I spend a lot of time with the surface, it is the inner life that I want to capture." He is never concerned merely with the feasible.

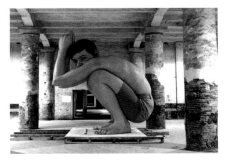

Boy, 1999

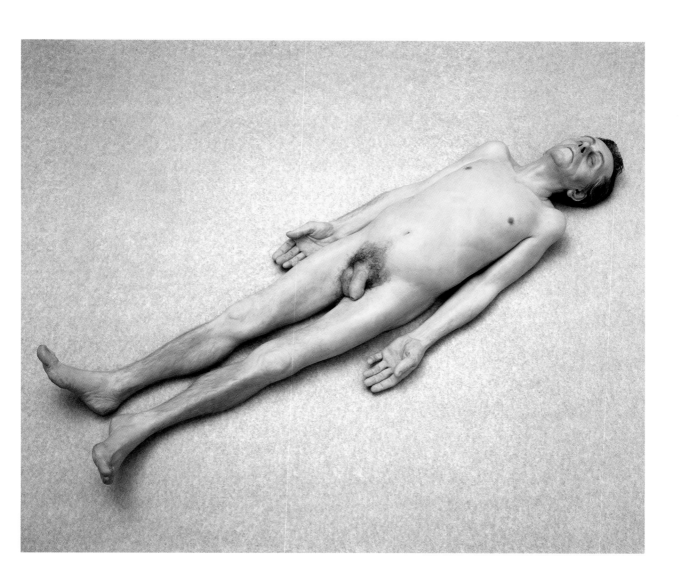

Soir (self-portrait with Felka Platek)

Oil on canvas, 87 x 72 cm
Osnabrück, Felix-Nussbaum-Haus

**b. 1904 in Osnabrück,
d. 1944 in Auschwitz**

Felix Nussbaum left behind this portrait of himself with his wife Felka Platek, *Soir*, dated June 1942, when he was forced to flee from his Brussels studio in the autumn of that year. The reason for their flight was the Nazi clampdown on Jews in Belgium, which reached its climax with the so-called "Yellow-Star Decree", and finally deportations to the extermination camps. This and other attempts to escape eventually came to nothing: in the face of the Allied advance, the last of a total of 26 deportation trains left the transit camp in Mecheln on 31 July 1944. On 2 August it arrived at Auschwitz, where Nussbaum and his wife were murdered.

In this double portrait it can be seen very clearly that the couple were in fear of their lives. In a bare room we see a young woman, naked but for her shoes and a coloured necklace, holding a branch in her right hand, arm in arm with a young man, likewise naked from the waist up, with his trousers open just enough to reveal the top of his public hair. He is standing on a crumpled copy of the newspaper *Le Soir* (The Evening), which gives the picture its title. As the official gazette of the German military government, it is the bringer of bad news. Behind the man there is an opening in the wall, on whose parapet stands a broken jug, and through the opening we can see into the street. On one corner a youngish man is waiting with folded arms, while an older man is moving off with the aid of a stick towards a dead tree. Both figures express loneliness, and their hard outlines are reminiscent of similarly lost-looking figures seen in Pittura Metafisica, the movement founded by Giorgio de Chirico. In both cases, secrets seem to be hidden behind seemingly everyday things – a street, a row of houses.

Nussbaum in addition includes symbols of the protagonists' specific plight: the jug is broken beyond repair, the branch in the woman's hand is doubtless an olive branch – but the young woman is allowing this symbol of hope to hang down forlornly. Between the man and the woman, the striped carpet is ruckled, and over the fold Felka Platek seems to have placed her own shod foot on the naked foot of her husband, reversing a motif found in medieval marriage pictures, where domestic power-relationships are sometimes suggested by the husband's shoe on his wife's foot. The fold in the carpet and the position of the feet may indicate divergent opinions on the part of the protagonists: Nussbaum remains in Brussels because his wife does not want to flee with him.

The woman with her dreamy, devoted girlish face, her shaded almond eyes, her feminine curves, and the man with his muscular body are in an awkward and somewhat aloof embrace: the linked arms look more as if they were giving each other mutual support. The attitude of the pair comes across as a vain attempt to assert themselves through their closeness and shared intimacy against the hostile and threatening outside world. We are not concerned here, as we are in the case of Christian Schad or Anton Räderscheidt, with a basic difference between the sexes which cannot even be overcome by sexual intercourse, but rather with a failure due to pressure and menace that seems to come from outside. The hole in the wall, giving on to the hostile exterior, brings these outside pressures so close to the inner space that the logic of the picture is torpedoed, while making clear the causal connexion between the interior and exterior worlds.

"when I perish, don't let my pictures die!"

Felix Nussbaum

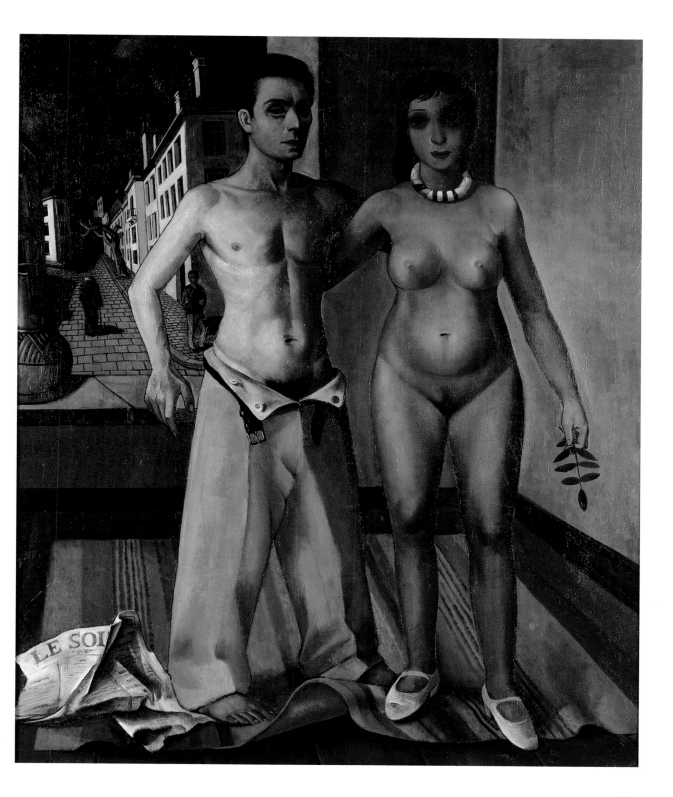

Black Iris III

Oil on canvas, 91.4 x 75.9 cm
New York, The Metropolitan Museum of Art, Alfred Stieglitz Collection, 1969

**b. 1887 in Sun Prairie (WI),
d. 1986 in Santa Fe (NM)**

With the flower pictures, which Georgia O'Keeffe painted from 1924 until the late 1950s, she is venturing on to terrain with feminine connotations. And yet her pictures, which usually depict large-format close-up details of plants, have nothing to do with conventional still-lifes with flowers.

Black Iris III, dating from 1926, is one of these suggestive flower pictures that oscillate between the abstract and the figurative, and inexorably calls to mind the female sexual organs: the dark opening in the centre, which draws the gaze into the depths, is surrounded by delicate, pastel-coloured petals. This sensuous exploration of form, which attracts us through its sparing use of paint and the suggestive shading, had the result that even contemporary critics enthused about the aesthetic balance and the erotic effect. O'Keeffe gave the same attention to the tobacco-plant, the camomile and the so-called skunk-cabbage, always greatly enlarging individual leaves, which became her personal theme. She gave her reasons in 1962, somewhat tongue-in-cheek: "I realized that were I to paint the same flowers so small, no one would look at them because I was unknown. So I thought I'll make them big like the huge buildings going up. People will be startled, they'll have to look at them — and they did."

Similarly unpretentiously sensuous are the photographs taken of her face and body by her husband, the famous photographer and promoter of avant-garde European art in America, Alfred Stieglitz. Sensitive and without false modesty, these pictures speak of being overwhelmed by what is seen, without robbing it of its aesthetic innocence. O'Keeffe herself said of the Stieglitz photos that they had helped her to find her individuality and to use painting to say what she wanted. However, Stieglitz wanted to nail O'Keeffe down to particular subjects, for he too saw in her art a gender-specific quality realized in artistic expression. But O'Keeffe was aware that she had been typecast by her flower pictures, and went against Stieglitz's advice by turning to other subjects as well, such as the "masculine" motif of the skyscraper.

Her cityscapes from the years 1925 to 1930 are full of drama. From 1933 she lived on and off in New Mexico, setling for good in 1949. The landscape, with its mountain massifs and remnants of bones and skulls, proved an inexhaustible source of inspiration in the second half of her life. Her technique always oscillated between still-recognizable gestures on the one hand and reduction on the other, just as her personality seems both to be expressed in her pictures and at the same time to withdraw from them — for example, she never signed her oil-paintings on the front. O'Keeffe was the first woman to be given a retrospective in the Museum of Modern Art. That was in 1946. When she died at the age of 98, she left a consistent life's work whose popularity has nothing whatever to do with lack of quality.

"Nothing is less real than Realism. Details are confusing. Only by selecting, omitting and emphasizing do we advance to the true meaning of things."

Georgia O'Keeffe

Female Model on Eames stool

Oil on canvas, 122 x 152.5 cm
Courtesy Adams Gallery, New York

b. 1924 in Pittsburgh

Philip Pearlstein has made the nude the focus of his attention since 1960. The 1978 *Female Model on Eames Stool* is a classic example of his style, evenly illuminating and bringing out every detail of the body.

The Eames stool itself is a design classic; on it is sitting a woman whose face and shoulders are cut off by the top edge of the picture. The floor is covered by a geometrically patterned red-and-blue carpet, which partly covers the skirting board of the greyish-white wall in the background. The woman's right knee and left foot are also partly out of the picture, while her sinewy hands are placed one over the other in her lap, and thus in the centre of the painting. The somewhat swollen veins on these hands suggest that she is no longer a young woman. The rest of her body is flawless, the stomach is firm and muscular. Part of her pubic hair is visible, and her skin is pale against the black leather, which takes up the colour of the hair.

From this description, and without the benefit of the picture, one might think the effect to be erotic, but this is not the case: the depiction comes across as objective and so sober that there is no intimate tension or sexual charge to be felt. Nor was it intended by Pearlstein, just as he has no interest in the personality of his models: "The sitter's personality may be reflected from the particular form of his features, but I'm not trying to present his personality."

The central feature of his depiction is the bright artificial light, which eliminates warm tones from the picture, and which Pearlstein uses, just as he uses the composition and the "cropping" technique, in order to anchor his subjective gaze on the subject. Unlike the Photo-realists, whose works he regards as purely mechanical reproduction once they've made their choice of photographic original, which they needn't even have taken themselves, because in his eyes it is impersonal, Pearlstein settles down to a long period of observation. The model's movements, which result in constant slight shifts of form, such as muscular contractions, generate a tension which for him makes his work a challenge. Encompassing the anatomy of the sitter, made possible by spending a long time with his models, leads to precise physical representation, which has little to do with Photo-realist transformation and even less to do with expressive deformation: "I rescued the figure from its tormented, agonized condition given to it by the expressionistic artists, and the cubist dissectors and distortors of the figure, and at the other extreme I have rescued it from the pornographers and their easy exploitations of the figure for its sexual implications. I have presented the figure for itself, allowed its own dignity as a form among other forms of nature." The fact that the pictures are always cropped, and that the face of the model is often invisible, is not only an indication of the equal status of everything that is seen, but also that the choice of the artist is his own and determines the picture. These de-emotionalized nudes derive their intensity from their closeness.

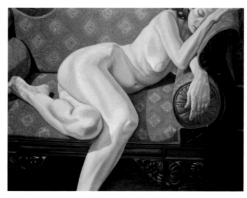

Female Model Reclining on Empire Sofa, 1973

girl tennis-player

Oil on canvas, 100 x 80 cm
Munich, Pinakothek der Moderne

**b. 1892 in Cologne,
d. 1970 in Cologne**

Anton Räderscheidt was the only artist from Cologne to be exhibited as a leading exponent of Magic Realism at the Mannheim "Neue Sachlichkeit" exhibition in 1925. At the start of his career, Räderscheidt experimented with the various possibilities of modern art, before joining Max Ernst's Cologne-based Dada group, and not long afterwards painted Constructivist works.

In his figurative painting, his biography and his pictorial world seem to be heavily mixed: in 1921 Räderscheidt discovered the theme of the lonely couple, which he took up time and again in the years to follow: the archetypal picture, *Encounter I*, dating from that year, is lost. Anyone who has ever seen August Sander's portrait of the artist with his first wife, the painter Marta Hegemann, will recognize the man with the bowler in his numerous self-portraits and pictures of couples, which express isolation in archetypal fashion.

The 1926 *Girl Tennis-player* is one of a whole series of sports pictures including *Nude on the Bar, Nude on the Trapeze*, or *Tightrope Nude,* which are all lost. The subject's naked body is presented monumentally, the posture of the powerful young woman, who has quite obviously never held a tennis racquet in her life, is statuesque, while the correctly dressed man in the bowler hat is outside the court in the background, a long way off and separated from the girl by a fence. As late as 1926, Räderscheidt regarded this hat as the "only possible head-cover": together with the suit, it represents a kind of uniform, which makes individualities seem interchangeable. His facial features are heavily simplified, but in view of Räderscheidt's tradition of self-presentation, we may presume that this is a self-portrait. The tension in this unusual situation between the observer, whose hands cannot be seen, and the object-like woman generates an erotic atmosphere with a dream-like quality. Räderscheidt's pictorial language was moulded by the Pittura Metafisica works produced between 1910 and 1920, which he became acquainted with through the magazine *Valori Plastici*. From them come the motifs of the deserted places with their isolated, sculptural dolls (Italian: *manichini* = model), as can be seen for example in the works of Giorgio de Chirico, figures without a will of their own, produced by classical painting techniques and positioned by the artist. Räderscheidt takes over their frozen character, but gives them individual features. But even in Räderscheidt's pictures, there seems to be a mingling of the real and imaginary worlds. Confusion is aroused because the sculpturally modelled bodies of the nudes lack nipples or pubic hair, like shopwindow dummies. Räderscheidt seems far removed from optimism of any kind; the distance, and the difference in costume and custom between the two figures, make their isolation look hopeless, and there is the lingering suspicion that the phenotype of the strong woman is preparing the way not for true emancipation but for a new form of terror.

The Nazis' "degenerate art" campaign and his own flight to France and then to Switzerland have resulted in little of Räderscheidt's œuvre of the 1920s and 1930s being preserved, while after the War he suffered from the prevailing artistic fashion which dictated that figurative art was not modern.

Self-portrait, 1928

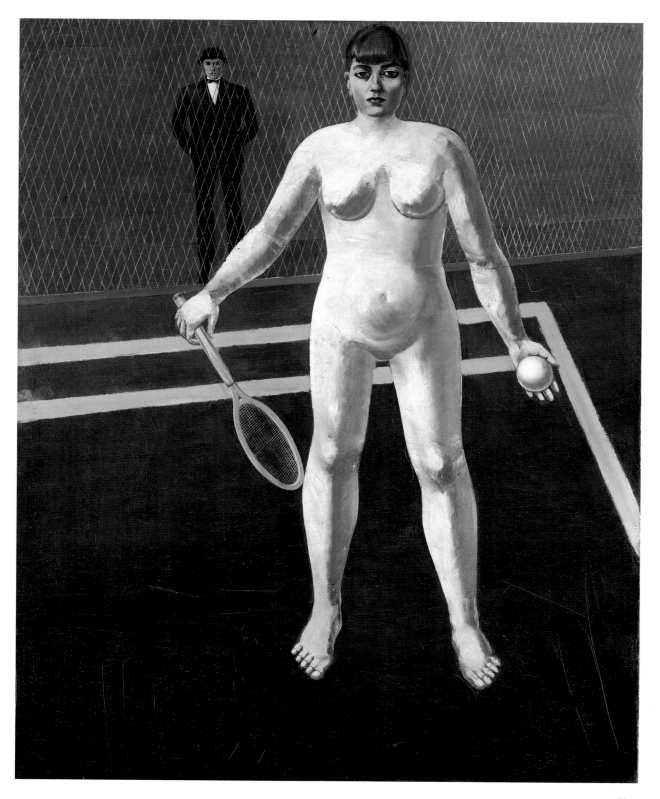

ᴅead woman 1–3

From the cycle "18 October 1977", oil on canvas, 62 x 67 cm, 62 x 62 cm, 35 x 40 cm
View of installation at the exhibition "Gerhard Richter – 18. Oktober 1977", Museum Haus Esters, Krefeld 1989

b. 1932 in Waltersdorf

At first Gerhard Richter trained in advertising art and as a scene painter in Zittau, before studying at the Akademie der bildenden Künste in Dresden. Fleeing from East Germany to the West in 1961, he continued his studies as the Kunstakademie in Düsseldorf, where later he was professor for a long time.

Richter's *Atlas*, a compendium of photographic reproductions comprising almost 6,000 pictures, which he started in the 1960s, serves as the stock of motifs for his photo-painting. This securing of evidence of fragments of reality seems to involve the iconography of chance in a major role. But the motifs are not always innocent; the store of pictures of a visually based culture must also include subjects such as the nine motifs which form the basis of the 15-part sequence entitled *18 October 1977*, which was painted in 1988. (It was on this day that, following the storming of a hijacked German airliner at Mogadishu by German special forces, the kidnapped industrialist Hanns-Martin Schleyer was murdered by the "Red Army Faction" terrorist group, and the imprisoned members of the group, Baader, Ensslin and Raspe, committed suicide in Stammheim jail near Stuttgart.) These images cannot be understood as the expression of pure chance, but represent a factual and emotional complex which provides the subject-matter of debate even today.

The pictures are painted in black-and-white on the basis of press and police photographs. They unfold a suggestive power, pointing to photography as the starting medium, and thus to the documented event (in this case, the suicide of Ulrike Meinhof, another leading member of the group, who had hanged herself in her Berlin prison cell some time previously). However the smudging, sometimes leading to unrecognizability, emphasized that painting is the chosen technique. Alongside a portrait of Ulrike Meinhof as a teenager, we have the *Dead Woman* triptych. The same shot is used three times: a bust of Meinhof lying on her back, her neck slightly stretched. The formats of the pictures grow smaller from left to right. On each, the marks of strangulation are visible on her throat. The central picture is shortened into a square: it is here that our gaze returns, after vainly searching the other pictures for discriminating marks. Richter himself described the deaths of the prisoners in Stammheim as an exceptional misfortune on account of the power of their ideas, albeit with the proviso that this sequence was not to be seen as taking up their cause. Even so, it recalls Christian iconography, for example Holbein's pictures of the dead Christ, and thus a victim or sacrifice which transcends all doubts. For an exhibition at the Haus Esters museum in Krefeld, Richter noted: "The deadly reality, the inhuman reality. Our revolt. Impotence. Failure. Death. – This is why I paint these pictures." The ambivalence grows with each of Richter's utterances.

It is telling that the cycle found no buyers in Germany. The attempt to reflect on the Baader-Meinhof myth, and thus to transform it into an insightful reminder, is not popular in that country. The painterly blurring resulting from the grey veil which Richter hangs over his pictures can be interpreted as a kind of levelling, but may also be seen as pointing to the denial which continues to characterize our approach to the phenomenon of terrorism, and which is reflected in the alienation thus created. Richter's artistic confrontation with history and with the present consists in an analysis of mass-media pictures: as paintings, they must be distinguished both from reality and from the photographs on which they are based. This gives rise to one of the rare examples of reticent historical pictures in tune with our times, pictures which demand an appropriate attitude on the part of the beholder.

"ʜow can ɪ paint today, and above all: what?"
Gerhard Richter

Detroit industry, or man and machine

Mural, south wall, 4 wall surfaces each divided into 5, 8 and two times 7 panels,
painted surface in total 433.63 square metres
Detroit, The Detroit Institute of Arts, Gift of Edsel B. Ford

**b. 1886 in Guanajuato,
d. 1957 in Mexico City**

As the most important Mexican painter of the first half of the 20th century, Diego Rivera was so well known in the neighbouring United States that he was commissioned there to design and execute large murals in several cities – San Francisco, Detroit and New York.

In 1932, Rivera was invited by the Detroit Arts Commission chaired by Edsel B. Ford to decorate the inner courtyard of the Detroit Institute of Arts with a cycle of frescoes on the theme of *Detroit Industry, or Man and Machine.* The Commission chose Rivera because, as one of the directors of the municipal art gallery wrote, he had "built up a powerful narrative style of painting, which makes him, it is safe to say, the only man now working who adequately represents the world we live in – wars, tumult, struggling peoples, hope, discontent, humour and speeding existence."

Rivera began preparations in April the same year, making hundreds of sketches and studies of the individual production phases, which he consulted, together with numerous photographs by the official company photographer when painting the wall surfaces, a process which lasted from July 1932 to March 1933. Rivera's enthusiasm for the commission was so great that he declared himself ready, for the contractual 10 000-dollar fee, to paint not only the 100 square metres of the north and south walls as agreed, but all four wall surfaces, in order to be able comprehensively to depict the relationship between man and machine.

On the smaller east and west walls, Rivera depicted the origins of human life and of technology, that is to say, the new water-borne and airborne technologies. The monumental frescoes on the north and south walls are largely devoted to the manufacture of the V8 engine and the bodywork of the new Ford automobile, which had rolled off the assembly line for the first time a few months earlier. The depiction of the factory hall on the south wall was based on studies made by Rivera of the various factories owned by the Ford family, in particular the River Rouge complex also documented by Charles Sheeler. In the medium of the mural, Rivera created an aesthetic of the machine age whose optimism is surprising. In view of the painter's Marxist convictions, the presentation of capitalist productions sites is extraordinarily positive, and bears witness to the great fascination they exerted upon him. The comparatively harmonious synthesis of man and machine does not reflect the actual situation of the workers during the Depression, with its unemployment, strikes and public soup-kitchens: in 1932, Ford's production was just one-fifth of what it had been in 1929.

This mural is painted in Rivera's personal style, a self-willed mixture based on studies of Italian Renaissance frescoes and pre-Columbian sculptures from the "land of the gods", combining symmetry and statuesque forms with a narrative technique. The similarity of the central production machine with an Aztec Coatlique figure is striking. While Edsel B. Ford in Detroit issued an official declaration in defence of Rivera in the face of public attacks, the artist had less luck with his mural for the Rockefeller Center in New York: there, a portrait of Lenin, which Rivera refused to paint over, led to a major row and the destruction of the picture.

"Through all that I have painted it is clear to me that I need at least four more lives to realize what I still want to paint."

Diego Rivera

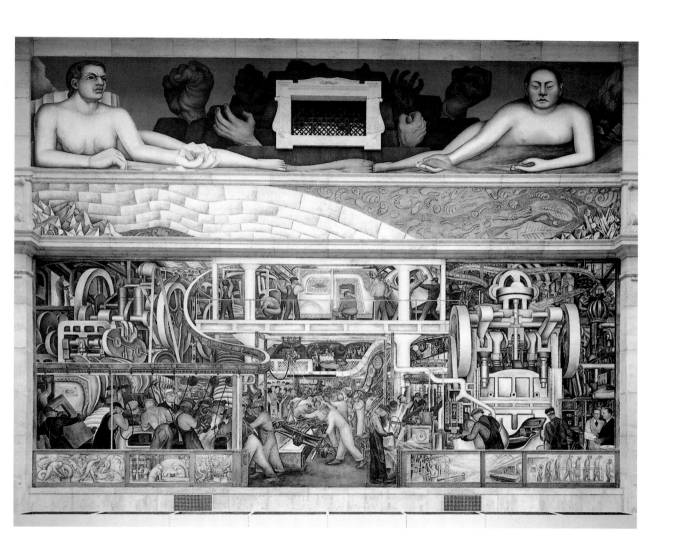

self-portrait with мodel

Oil on wood, 76 x 61.5 cm
Private collection

**b. 1894 in Miesbach,
d. 1982 in Stuttgart**

Christian Schad is regarded as one of the leading exponents of Neue Sachlichkeit, and according to Wieland Schmied, is the "prototypical possessor of the 'cool gaze' which distinguishes this movement from earlier forms of Realism".

With his portraits painted in the 1920s, including this 1927 *Self-portrait with Model*, Schad captured the atmosphere of a particular class of society while remaining aloof from it. It is these pictures of an era which form the lasting legacy of the artist. In addition, during a stay in Switzerland which allowed him to avoid military service in Germany, he developed in 1919 a process for the production of contour pictures using light-sensitive photographic plates. Christened "Schadographs" by Tristan Tzara, they brought him a certain renown.

Photographic ways of seeing also influence Schad's paintings: the fragmented townscape behind the couple –the outlines of urban buildings can be made out through the thin curtain material – can be understood as the result of his investigation of photography as a way of capturing the world. The same could be said of the precise depiction of the persons and objects in the picture, for example the meticulously delineated orchid behind the woman, an indication of the sexual charge present in the situation.

The bust of the artist in the foreground is characterized by two things in particular: his sceptical gaze, which seems to be directed straight out of the picture and at the beholder, and a transparent greenish shirt, which emphasizes his nakedness, as every single hair on his chest is visible beneath it. This revealing cover increases the tension in the picture because it is in such contrast with the flesh-tints of the woman, and is reminiscent of the subtly diaphanous garments in an altarpiece by the Florentine Mannerist Pontormo. The man is obviously sitting on the edge of a bed, the woman with her beautiful body, its nakedness emphasized by the red stocking cut off by the edge of the picture and by the black ribbon round her wrist, can be seen in profile, her pubic region hidden by the man's body – although the beholder's gaze is drawn towards it by the slim index finger of her left hand. Her self-willed face with the sharp nose is marked by a *sfregio*, a scar left by a passionate husband or lover as a sign of his jealousy. According to Schad, Italian women wore this disfigurement with pride, as a sign of how passionately they were loved.

There is however very little passion, let alone intimacy, to be felt in the picture; following the act to which the rumpled bed seems to bear witness, the atmosphere is one of aloof coolness. It was Schad's wish that the decadence of the scene, which precisely captures the zeitgeist in an admittedly privileged class during the 1920s, should not be suspected of illustrating any specific situation. He himself described his paintings as symbols, arising from intuition. What we have is a picture, painted with what has often been described as old-masterly precision, of post-coital alienation, comprehensible also for today's beholders.

"оesire is the sole fraud that I wish permanency."

Walter Serner

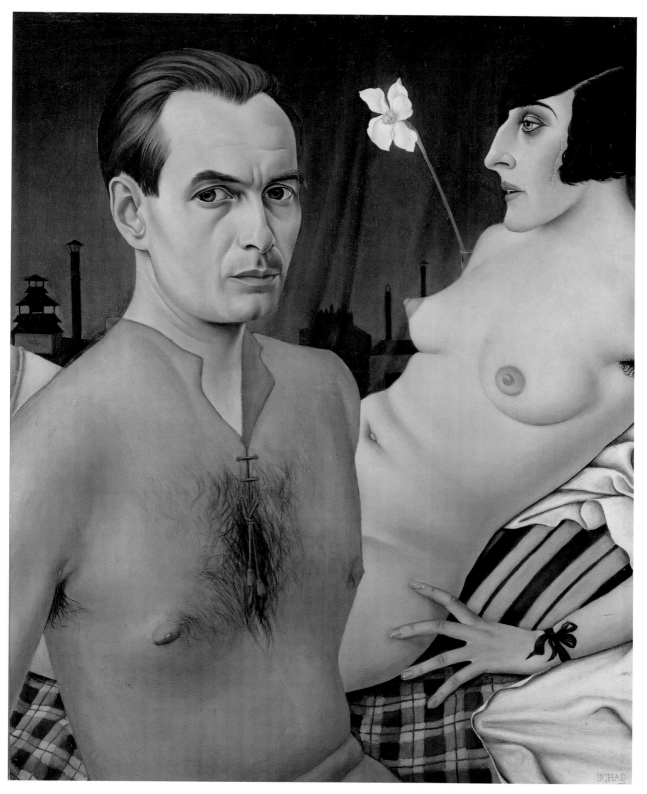

вartolomeo vanzetti and nicola sacco

From the series "The Passion of Sacco and Vanzetti", tempera on canvas, 214.6 x 121.9 cm
New York, Whitney Museum of American Art, Gift of Edith and Milton Lowenthal in memory of Juliana Force

**b. 1898 in Kaunas (Lithunia),
d. 1969 in New York**

Benjamin Shahn, who emigrated 1906 with his family from Lithunia to New York, was one of the great critical Realists of American painting during the 1930s. After being trained as a lithographer, he took a number of painting courses and studied at the National Academy of Design, before sharing a studio in 1929 and 1930 with his friend Walker Evans, who inspired him to become a photographer. Many of his photographs served him as raw material for his socially committed paintings. His 25-part cycle *The Passion of Sacco and Vanzetti*, painted in 1931/32, uses existing press material and relates to an earlier judicial scandal. Nicola Sacco and Bartolomeo Vanzetti were two Italian immigrant workers in America, and as active members of the left-wing trade-union movement, had organized strikes and demonstrations. In 1920 they were accused of a murder with which they probably had nothing to do, and after a highly dubious trial, were sentenced to death. Protest and solidarity campaigns at home and abroad failed to save them. Although hundreds of thousands of people demonstrated against the unjust conviction and demanded their release, Sacco and Vanzetti were executed on 22 August 1927.

The conviction and execution were thus seen as a state act by which extremists were to be eliminated and the labour-union movement intimidated. *Bartolomeo Vanzetti and Nicola Sacco* shows the two defendants handcuffed together and with their heads at an identical angle. Sacco's gaze, however, seems to be directed straight at the beholder. Dressed formally for the trial in suit and tie, Sacco and Vanzetti sit in front of the coffered courtroom wall on a bench upholstered in red. The similarity with the faces recognizable from photographs is clear, but the transfer to the painted medium comes across as almost caricature-like, for the graphic elements are dominant. The simple immediacy of the depiction is intended to address the beholder directly and in somewhat shrill fashion, emphasized by the strong colours and clear contours. Critics have occasionally denounced this aspect, saying the picture was "popular like a postcard, with a human characterization blander than an insult and a color as fresh as a familiar folk-object – a painted harness or a tavern-sign." These pictures established Shahn as a painter: in 1932 the Whitney Museum of American Art chose one of his paintings for its first Biennale, and the same year, he was invited to take part in an exhibition of murals at the Museum of Modern Art. He assisted Diego Rivera in executing the latter's mural at the Rockefeller Center, a painting that was destroyed in 1933 before it was finished because it contained a portrait of Lenin.

The title of the cycle, *The Passion of Sacco and Vanzetti*, was intended to associate the persecution and deaths of the two workers with the Passion of Christ. Shahn's depiction is authenticated by photographic evidence, but its simplified structure makes the story more accessible, while the choice of subject preserves the memory of something that might otherwise have long since fallen into oblivion.

**Bartolomeo Vanzetti and Nicola Sacco,
1931/32**

city interior

Aqueous adhesive and oil on composition board, 55.9 x 68.9 cm
Worcester, Worcester Art Museum

**b. 1883 in Philadelphia (PA),
d. 1965 in Dobbs Ferry (NY)**

First Charles Sheeler established himself as a painter, and in 1913 he was represented at the New York Armory Show with six paintings. His devotion to photography, in particular to architectural photography – in which financial considerations also played a part – made him the pioneer of a Neue Sachlichkeit-related camera art in America, but at the same time, photography served time and again as a source for his paintings. Thus while the legendary photographs of the Ford works, *The Plant*, were commissioned by the company in 1927 as advertising material for the functionality and beauty of the Machine Age, Sheeler used one of the unpublished pictures eight years later as the starting point for his painting *City Interior* – on entering the factory site, he recognized the possibility of using the material for his painting too: "When I arrived, I immediately took the opportunity to open the other eye, and then I thought that maybe I could get a few paintings out of it too."

From a raised vantage point, we are confronted with the smoothness of the machines and their proportions, apparently not imagined with human beings in mind; the small figures moving between the tracks and on the steel walkway serve at best to indicate the scale. Human surroundings, let alone humans to control the machines, can be seen neither in this nor in the other paintings. The precision of the pipes and the raised viewpoint are reminiscent of Sheeler's Straight Photography, but the transformation into painting shifts the view: the fact that the subject is thought worthy of painting seems to make it a source of information, beyond the purely documentary aspect, on changed conditions of life and work. For reasons of market strategy, Sheeler did not want it to be known that this and other paintings were based on photographs. But although he stood in the shadow of his contemporaries Alfred Stieglitz and Paul Strand, it was the picture of the Ford Motor Company's gigantic criss-cross conveyor belts in River Rouge that was selected for the cover of the catalogue of the exhibition "The New Vision" in the New York Museum of Modern Art in 1989.

But even before that, Sheeler had already been accorded recognition by the photographic scene: two decades after he had photographed the conveyors in River Rouge, Walker Evans took a photograph at the same spot. Sheeler's aloof pictures were, as Edward Steichen once said, "objective before the rest of us were". His paintings, which concentrate entirely on the exterior, or surface, are, with their sharpness and clarity resulting from reduction, an illuminating indication of why he and the other "precisionists", who celebrated machines and factories in this decided manner, were also called the "immaculates".

The seemingly sober vision of the industrial plant celebrates a utopian view of progress to which Rivera's frescoes also paid homage at the same time and with the same subjects. A propos of *City Interior*, Winslow Ames had already written emphatically in 1936: "It is not industry as industry seems, but the industry of our dreams, in which are mingled manifest destiny, the grandeur and loneliness of the prairies, and the old-fashioned immigrants' belief in sidewalks paved with gold." The impersonality of the photographic original combines with the subdued colour and the monumentality of the painterly approach to create a further "American landscape".

"you don't build the house first and then make a blueprint afterwards."

Charles Sheeler

powder тraces

From the series "Murder Investigations", various materials, 54 x 120 x 12 cm
Bremen, Neues Museum Weserburg, loan from private collection

b. 1930 in Galati (Romania)

Daniel Spoerri, born Daniel Isaak Feinstein, managed to flee from National Socialism to Switzerland – the homeland of his mother, whose name he assumed. He owes his fame to his so-called snare-pictures, created from 1960 on. Self-taught, he took up the visual arts in Paris starting with works in which objects such as crockery, glasses or cigarettes are scattered (seemingly) haphazardly on a flat surface, a tabletop, say, and stuck down, the whole then being hung as a picture on a wall. Later Spoerri started holding banquets with friends on this principle, and documenting them – the idea was to capture reality, as though in a snare. Heidi-E. Violand-Hobi describes this process as follows: "In these snare-pictures, which he continues to produce in ever-changing variations and developments to this day, we see the contradiction between immobilization and movement: the knives, forks and spoons stuck to the surface are interrupted in their natural movement, and the more the process is interrupted or stopped, the more they implore to be moved."

This former ballet dancer and director's varied œuvre includes performances as well as cooking-happenings, sculptures and assemblages of objects. But the playful topography of chance does not exclude serious themes, which go far beyond the *vanitas* motif with its indication of the transient nature of culinary excess. In the 1971 *Murder* series, which consists of nine boxes entitled *Murder Investigations*, the beholder's attention is drawn not playfully, but with frightening brutality, to phenomena of the world which seldom appear in an artistic context: unnatural deaths of people as a result of murder or suicide. In the three-part work *Powder Traces (Pulverschmauch)*, he combines three wooden boxes: in the middle is the archive photograph of a girl with a bullet hole in her forehead, including a caption

which tells us that the girl was murdered by her father: the skull of a small animal is fastened to this exhibit. To the left is a firearm, which we see both as a black-and-white reproduction, and also in reality, lying at the bottom of the box. In the right-hand box is a broken toy, the bust of a small doll, which takes up the form of the murdered girl, and by its side lie two reddish marbles. Yellow wax has been allowed to drip on to all three boxes, which may recall past times. Often Spoerri combines quite banal objects with pictures of the victims: an everyday rag, some object from the artist's immediate surroundings, becomes a lethal weapon, which derives its importance from the context. Thereby Spoerri adds the question of whether the threshold which someone needs to overstep in order to become a murderer may not be equally low.

For this series, he has rightly been called a "merciless realist". He confronts the beholder with the result of violence, and at the same time presents material with which we are surrounded all the time: possible murder weapons, along with private memories and pictures such as we see in magazines or know from crime and accident photo-reporters such as Weegee. In this way Spoerri forces us not only to think about the victim, but also to confront the question of responsibility for the crime.

> **"ı start with an idea and allow myself to be inspired by the object. мy art arises from itself."**
>
> **Daniel Spoerri**

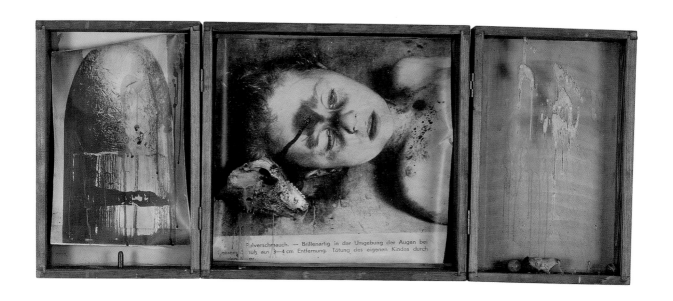

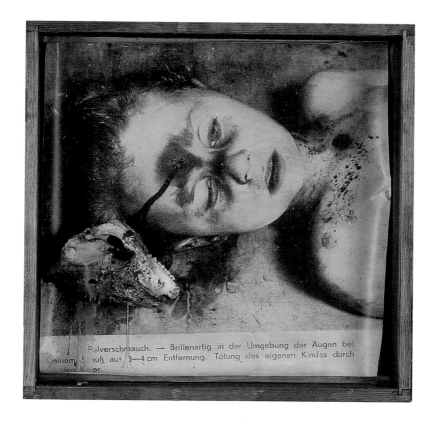

working-class and ıntelligentsia

Mural, central section, oil on wood, allover dimensions 2.70 x 13.80 m
Leipzig, University of Leipzig

**b. 1929 in Schönebeck,
d. 2004 in Leipzig**

Werner Tübke was one of the so-called Gang of Four (including also Bernhard Heisig, Wolfgang Mattheuer, and Willi Sitte), who represented the hallmark of communist East German art. He was a professor at the Academy of Graphic Arts and Book Art in Leipzig, and Rector of the institution from 1973 to 1976. He was treated as a "state artist". His painting varies from fulfilling the duty of socialist idealization on the one hand to, on the other, an individual mannerism which makes a mockery of any pragmatic unambiguity.

In 1970, Tübke won a competition for a mural on the wall of the Rector's office building at the newly rebuilt Leipzig University with his design on the theme of *Working-class and Intelligentsia*. This picture was not painted as a fresco on plaster, but in oils on wooden planks which are fitted together and held in place by a steel construction. The picture, which measures 2.70 x 13.80 metres, took two years to prepare and one year to execute, being finally completed in 1973. Uniting two clearly different groups in society, it depicts more than a hundred figures, all based on real people. Tübke did not photograph them, but painted most of them individually. "The fact that we have film, photographs etc. is all very well," explained Tübke, "but as far as needs and tasks in the visual arts are concerned, I take not the slightest notice of them."

Alongside a group of theoreticians, there are scenes from the university's computer centre, a physicist developing formulae, as well as discussing them with his students, and forming the transition to the depictions of the working-class, there is a scene in which the artist and his wife are bending down over their children. Further to the right we see building workers on a ramp and on scaffolding steps, and

then, in a powerful upward movement, a brigade of carpenters are portrayed. The crowd of people is structured by colour and changing light; within this crowd, each person plays his or her individual role as part of a social interaction. This was not the case in the first draft of the picture, where a prominent representative of society was given an equally prominent position in the picture. The existing balanced group portrait could not be less hierarchical in its treatment of the theme.

Unlike the painting *The Commendation* by Wolfgang Mattheuer, which was painted in the same year, *Working-class and Intelligentsia* exhibits the optimism demanded by the state in the celebration of the great social utopia of a balance of opposites. However, this does not derive from immediately true-to-life depiction: the protagonists are shown in histrionic poses, an indication of a Brechtian alienation effect, with the aid of which the scenes from the *vita contemplativa* and the *vita activa* are united in virtuoso fashion. The rejection of schematization and the liveliness of the depiction are rooted in the desire for transformation into social reality. Thus in 1982, Tübke wrote: "Very many of the works of enthusiasts for change that we see in contemporary exhibitions cause me displeasure. One reason may be that I am a Realist painter… As Realists, we have more important tasks, such as deepening our human image, encompassing human dignity." In his panorama *Working-class and Intelligentsia*, the socialist commission-artist succeeds in illustrating the solidarity that should be the aim of social transformation.

> **"ıt seems important to me today to possess capacity for utopia, including the retrospective capacity for utopia."**
>
> **Werner Tübke**

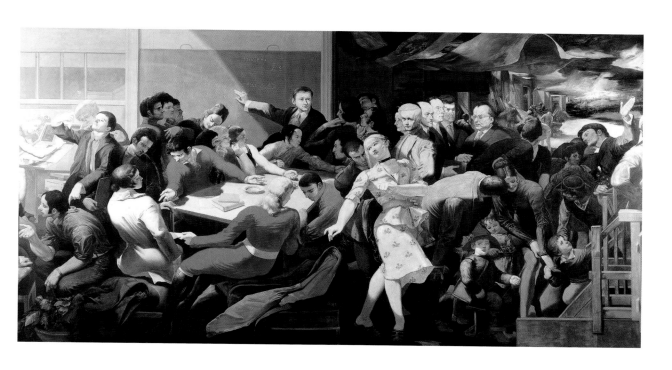

ᴛʜe ᴛʜinker

Cibachrome transparency on illuminated case, 229 x 216 cm
Private collection

"ᴀ picture is something that makes invisible its before and after."

Jeff Wall

b. 1946 in Vancouver

Since the late 1970s, the Canadian Jeff Wall, with his large-format photographic transparencies in illuminated cases, has become the most important exponent of staged photography. However the central motif for Wall, who also has aspirations in the direction of the theory of art, is the relationship of his works to reality. The filmic structures – he compares producing his mises-en-scène to making films – are there to get the beholder to reflect on current political and social phenomena. *The Thinker* relates to Albrecht Dürer's *Column in Memory of the Peasants' War*, an impracticable design for a memorial through which Dürer (1471–1528) presumably wished to identify himself with the peasant cause: he presents the figure being bayonetted in the back as a defenceless victim. In Wall's large-format transparency, mounted on an illuminated case, the sitter is depicted on a hill overlooking a waterside industrial landscape. But the "thinker" too was also killed from behind in the act of thinking: his gesture is reminiscent not only of Rodin's famous statue of the same name, but also of Dürer's engraving *Melancolia I*.

With his enormous hands and laced boots, Wall's protagonist comes across as a working man who seeks to preserve his dignity by, among other things, his formal clothing, the somewhat worse-for-wear suit. He thus seems to have accepted certain norms in order to keep up externally prescribed standards in a hostile world. This attempt was doomed to failure, and in Wall's grotesque mise-en-scène – quite obviously the person is not depicted as dead, but has the bayonet squeezed under his right arm – is theatrically exaggerated. Since both Dürer and Wall are presenting a victim, the sympathies of both artists seem to be with the underdog. But just as Dürer imposes no unambiguously partisan solution, Wall too assumes his public are also capable of taking the point. The picture's lack of essentiality turns this and other photographs by Wall into works that urge the beholder to consider once again both reality and the quoted original works.

Ideally this would lead to a change in our mode of seeing, in line with Wall's maxim that while aesthetic pleasure may not change the world, it does change oneself and one's relationship with the world. Thus Jeff Wall's picture *Dead Troops Talk* (1991/92), which shows a fictitious scene from the Afghanistan War with gruesomely disfigured dead soldiers communicating with each other, is, in the eyes of Susan Sontag, one of the few anti-war pictures that actually works, because it demonstrates the horror of war and the exclusion of the beholders. The dead in Wall's picture are not interested in the living, for the latter cannot comprehend what the former have suffered. With his mises-en-scène, Wall achieves a different effect from documentary photo-reportage, in which those photographed, often under the pretence of social commitment, are exploited for heart-rending pictures which a weary public notice only in passing. The recognition that that "truth" is not the same thing as "being true to the facts" opens up possibilities of the imaginary and the fictional, possibilities which provide a view of reality-phenomena in all their actual multiple ambiguity.

Albrecht Dürer, Column in Memory of the Peasants' War, 1525

american gothic

Oil on canvas, 79.9 x 63.2 cm
Chicago, The Art Institute of Chicago, Friends of American Art Collection

> **"I realized that all the really good ideas I'd ever had came to me while I was milking a cow."**
>
> **Grant Wood**

b. 1892 near Anamosa (IA), d. 1942 in Iowa City

It was *American Gothic* that made Grant Wood famous beyond the confines of his home state of Iowa; at the same time it was also the first of his pictures to be bought by a museum. A Regionalist, who, like his fellow-artists Thomas Hart Benton and John Steuart Curry was concerned with the restoration of an authentically American style of painting, he was nonetheless influenced by European art, as is evident from *American Gothic*. In the 1920s, Wood visited Europe a number of times, and the frontal double portrait of a farmer and his wife demonstrates his enthusiasm for the detail-obsessed painting of the Low Countries. The difficult-to-decipher mood of the mysterious couple is particularly reminiscent of Jan van Eyck's double portrait *The Arnolfini Wedding,* and at the same time it establishes Wood's familiarity with Neue Sachlichkeit. Above all, though, it is intended to reflect Wood's belief that an artist should "paint out of the land and the people he knows best".

Yet Wood's picture, which has since achieved the status of a national icon, and has been adapted by cartoonists and used for photo-montages more often than almost any other painting, only appears to depict a sturdy farmer from the Mid-West, with his pitchfork in his hand – in fact, the sitters are Wood's sister and his dentist. The fictitious image of the "Mid-Western pioneers" was intended to exploit the memory of common roots in order to revive an America that was in the process of disappearing. It is not without a measure of satire, and accordingly it was registered by the rural population without any great enthusiasm; no one wanted to be identified with these antiquated implements or such grumpy facial expressions.

There is a photograph of the same name by Gordon Parks dating from 1942, in which the use of the photographic medium creates a very much stronger connection with reality. In a room in which the American flag was displayed, Parks created, in the style of Grant Wood, an austere, frontal portrait of the black cleaner Ella Watson, with a mop in one hand and a broom in the other. She comes across as serious and tired, but in her expression, the beholder may discern a certain pugnaciousness. This woman with her bright eyes behind metal-framed spectacles is certainly not yearning for the return of the 19th century from which Wood's sitters appear to have been plucked. But the double allusion to the painting provides a commentary on the current situation at the time, namely the prevalent discrimination against black Americans even in the land of the free and home of the brave. Parks' *American Gothic* is not intended to consolidate the status quo: on the contrary, times have changed and these changes demand acceptance by society.

While Wood was often accused of restricting himself to a harmless idealization of times long past, one of his fellow Regionalists, Thomas Hart Benton (1889–1975) from Missouri, did not shrink back from depicting the problematic sides of rural life. *Flood Disaster*, dating from 1951, presents, in the typical dynamic, somewhat neo-baroque amorphous style which also characterizes his numerous murals, the results of a natural catastrophe. By contrast, Wood's ignoring of actual developments, his persistent depiction of stereotypes, led to his pictures' being celebrated as documents of a lost age only for a short period.

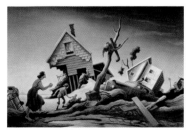

Thomas Hart Benton, Flood Disaster, 1951